MANGA
CRASH COURSE
FANTASY

w Anime and
Step-by-Step

MINA
"MISTIQARTS"
PETROVIĆ

I
IMPACT
CINCINNATI, OHIO
impact-books.com

CONTENTS

WHAT YOU NEED

Drawing Supplies

eraser

HB or mechanical pencils

ruler

smooth, heavy-weight drawing paper

Inking & Coloring Supplies

alcohol-based markers

black and colored inks

colored pencils

crayons

fine-line markers

liquid eraser

nibs and nib holders

paint brushes

permanent markers

watercolor paints

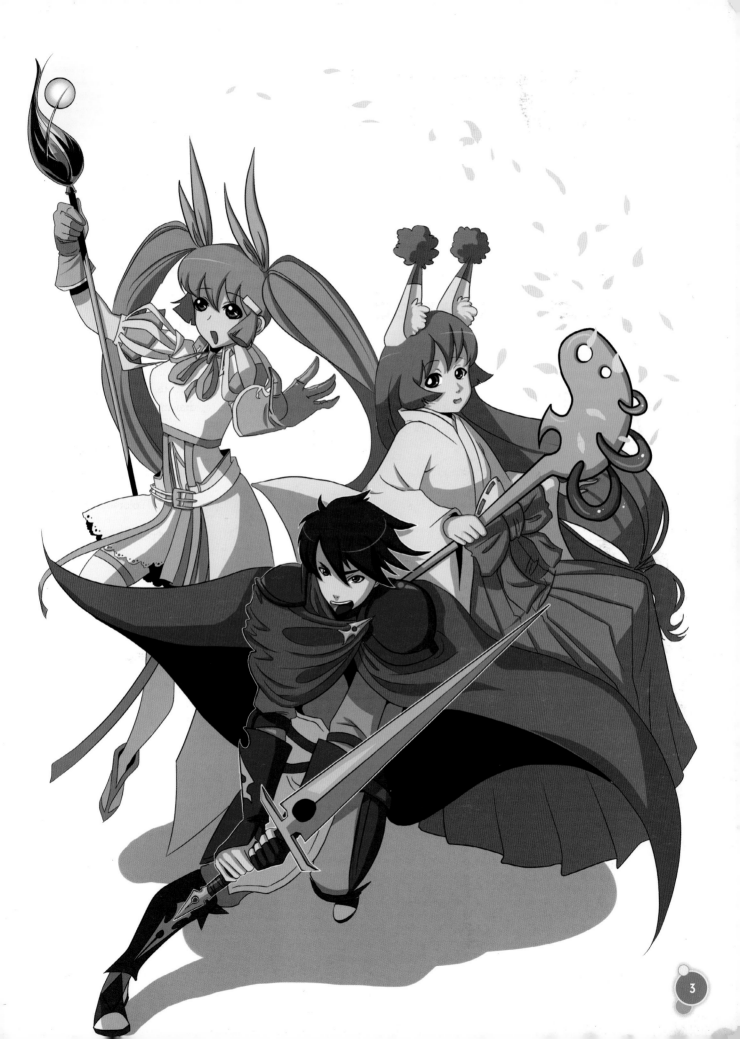

INTRODUCTION

Fantasy genre inspiration is all around us, from board games and video games to the legends and myths of fairy tales, and, of course, manga and anime. In manga, fantasy characters and creatures play roles in a unique adventure, sometimes representing the same stories over and over again but in a different way each time.

The fantasy genre has many sub-genres of its own. Sub-genres can include medieval themes, steampunk worlds and fairy realms. Some even have futuristic environments.

In this book, we will embark on an epic adventure together! You will learn how to draw fantasy manga creatures and characters, how to design the worlds they inhabit, and how to put them together into a story scene.

Get ready—your crash course to drawing manga fantasy starts... now!

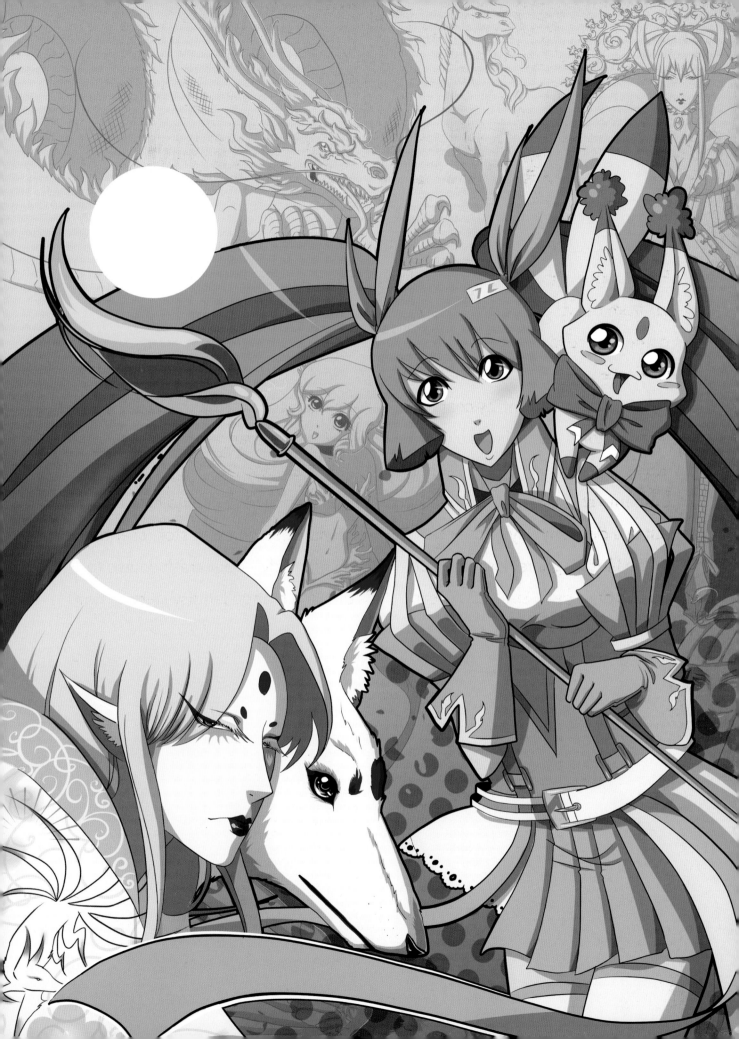

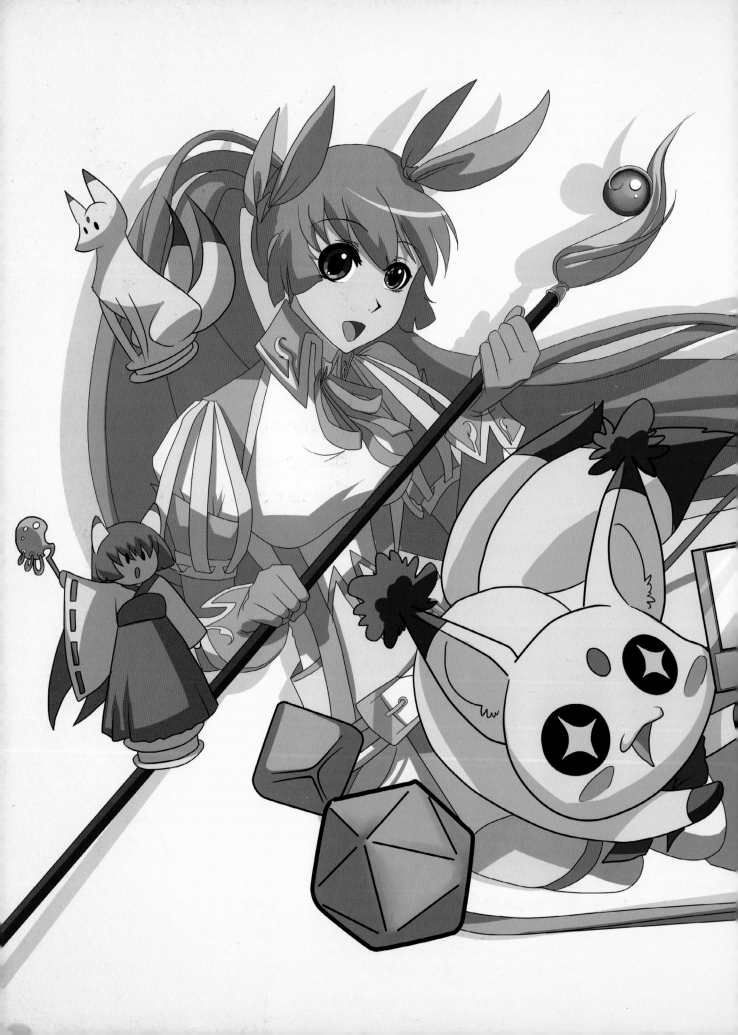

1

GETTING
Started

In this chapter we will cover the basic manga tools, as well as how to use them and make them last. Creating manga takes just a few simple steps, so you will learn all you need to know about getting started. We will conquer your drawing fears together, plus learn how to ink your work and make your manga from scratch.
Let's begin!

MEET THE MASCOTS!

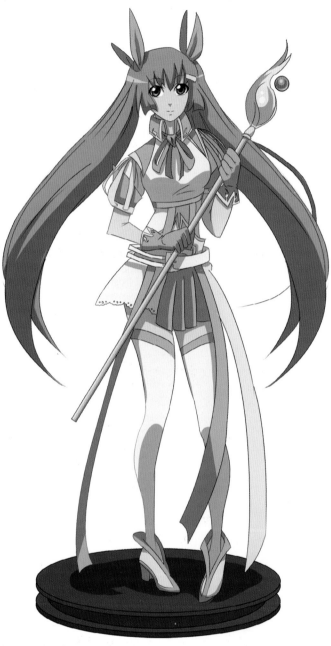

Mimi is the mysterious Shrine Priestess. She is also the human form of the two-tailed fox. Mimi will encourage you to fight on and use the magic of imagination.

Maya is the protector of the two-tailed fox. She uses the magic of art and illusions. Her symbol is a paint brush. She will lead you through this adventure with her friends.

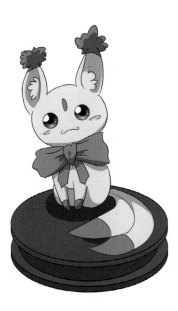

Small Fox Mimi will help to guide you along the way, doing her best to make you smile the entire time.

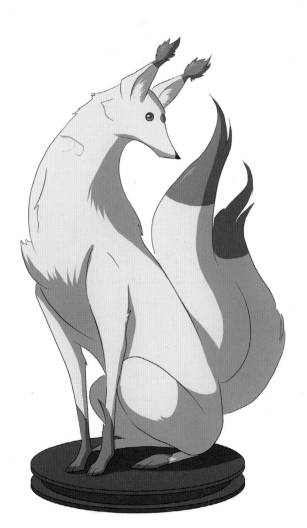

Marco is the brave knight who, just like you, is striving to improve and learn. That is why his symbol is the toughest tool to master—the inking pen.

When trouble comes along, you can count on **Big Mimi** to jump to the rescue to help you fight monsters and your fears.

DRAWING SUPPLIES

Fantasy manga requires the same basic tools as any manga illustration or manga panel. Tools can be categorized by their purpose.

ERASERS

Erasers are an important tool for drawing manga. It is best to use the type that are all one color, since multicolored erasers tend to smudge up the pencil lines you will want to erase eventually.

PENCILS

You can use regular school pencils or the mechanical kind. However, it is not recommended to use soft lead pencils for setting up manga lines. Usually the role of a pencil is to simply set up a sketch before proceeding to the inking part of the process.

Tip

Smooth stock paper is usually expensive, but a cheaper option is available. Laser printer papers have very similar properties and can work well as an alternative to stock papers.

PAPER

Papers with weight heavier than 90-lbs. (190gsm) are advisable for any type of manga art, especially when working with a lot of ink or watercolors. (Thin papers will buckle under a lot of water or ink.) Smooth papers are advisable for marker illustrations and thin layers of watercolors. Heavy-duty papers also work well for watercolors, but tend to have a rough texture.

INKING SUPPLIES

There are various inking tools that can be used for drawing out lines.

FINE-LINE MARKERS
Fine-line markers are thin markers with various tip sizes. They are specialized for precise lines.

PERMANENT MARKERS
A regular permanent marker is a cheap and precise tool for getting even coverage.

Tip
Always make sure that your inking tools are waterproof to avoid accidental bleeding of your line art.

INKS, NIBS AND NIB HOLDERS
Inking nibs and nib holders can be used with black and colored inks (and even white ink) to create special effects.

SUPPLIES FOR ADDING COLOR

Add color to your manga artwork with colored pencils, watercolors, pigmented inks or alcohol-based markers.

ALCOHOL-BASED MARKERS
Alcohol-based markers dry fast, which will save time if you are in a rush. However, each marker has only one cartridge of color, which means you will need to purchase a lot of them, including the refills.

PAINT BRUSHES
Paint brushes can be used to cover large areas with both paint and ink.

WATERCOLOR PAINTS
Watercolor paints can last a long time, especially if they are well pigmented. They create realistic colors and textures that cannot be achieved with markers

OTHER SUPPLIES

Here are some other useful supplies to consider adding to your manga art kit.

RULING AND INK NIB PENS

Ruling pens enable precise rendering of the thinnest lines and can be used for drawing in ink or any other fluids. They contain ink in a slot held between two flexible metal jaws that taper to a point. Nib pens usually consist of a metal nib mounted on a wooden handle. They are sensitive to variations of pressure and speed, producing a line that naturally varies in thickness. There is a wide range of exchangeable nibs available, so different types of lines and effects can be created.

WHITE OUT

White out tools are as various as inking tools. They can be used for white lines, splatter and particle effects, repairing ink spills and correcting imperfections. There are white out pens and markers, thick paint and even white ink. Most watercolor sets also come with a white watercolor pigment in the box.

RULERS

Rulers are useful for drawing building interiors and exteriors for a scene in a particular setting.

FIGHTING FEARS & FIXING MISTAKES

Many beginning artists will look at the works of their favorite artists and think it's not possible to ever be that good. But even our role models began with a single line.

A large part of that fear is just insecurity about the mistakes we might make. Yet mistakes are an important part of the process, because they teach us to grow and improve. Fixing mistakes takes time, but it is worth it.

Have no fear! We shall conquer this beast! All you need is patience and to accept that sometimes you will have to do it over. However, there are lots of tricks for making things go easier.

The most common mistakes made are inadvertently splattering ink or paint on the work, a misguided inked line, or an "off" pose or body proportion that went unnoticed at first.

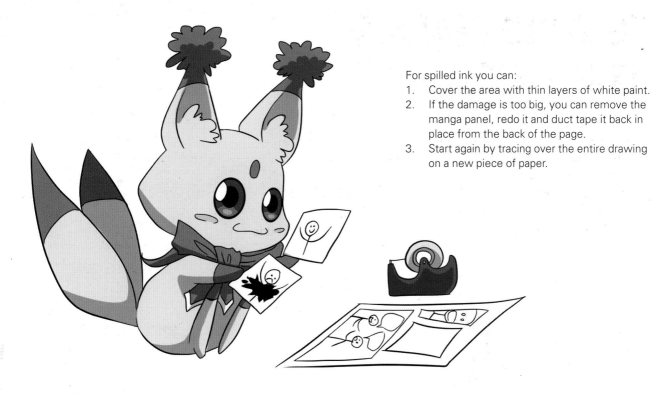

For spilled ink you can:

1. Cover the area with thin layers of white paint.
2. If the damage is too big, you can remove the manga panel, redo it and duct tape it back in place from the back of the page.
3. Start again by tracing over the entire drawing on a new piece of paper.

Improvise a tracing table by sticking your paper to a window. Or, you could put a phone with the flashlight turned on in a see-through plastic box and draw on top of it.

PROFESSIONAL EQUIPMENT CAN BE HOME MADE!

Tip

Trace your art for fixing mistakes, but don't trace other people's artwork. Tracing other people's work will not help you improve.

2

Basics

The secret to manga drawing is simplicity. In this chapter, you will learn how to draw fantasy manga-style features and bodies for both male and female characters. We will focus on tips for simplifying features such as eyes and noses, as well as body shapes—all while keeping a fantasy manga look.

POOF

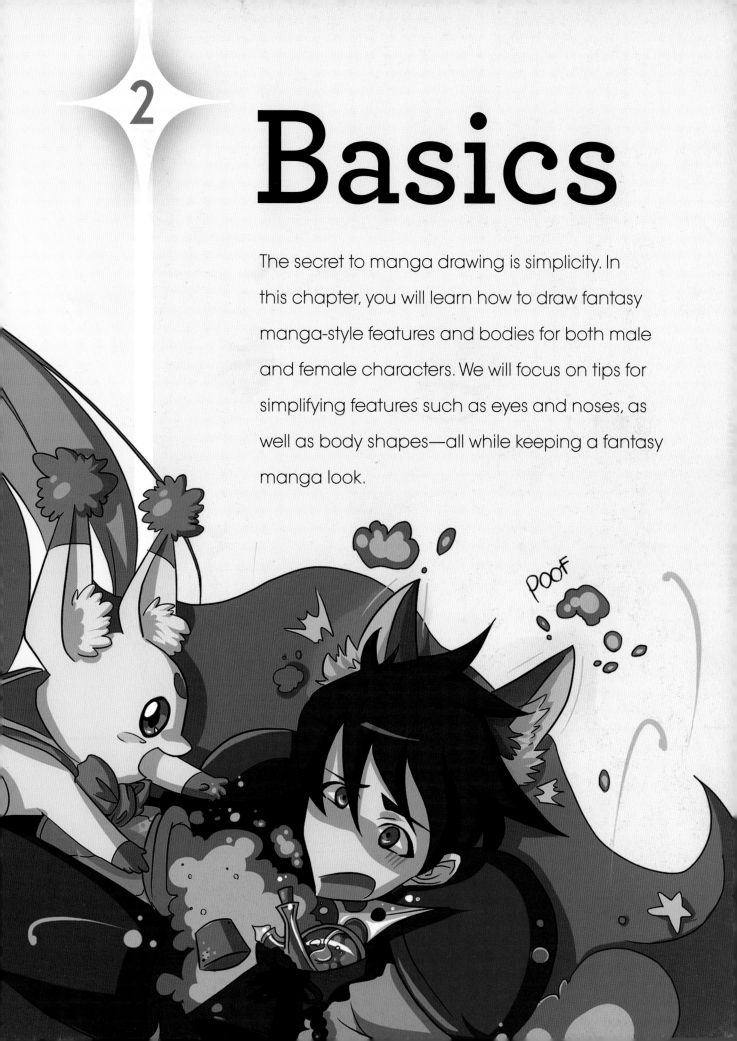

EYES

There are many ways to make your manga fantasy character's eyes appear magical.

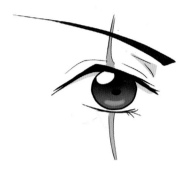

Place scars across the eyelid for the look of a seasoned fighter character.

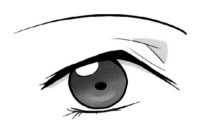

Eyes without an iris create a hypnotized, enchanted-looking character with a mysterious appearance.

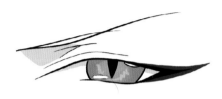

Animal eyes give an exotic, wild look to a character. Add a little red eyeliner for a splash of inspiration.

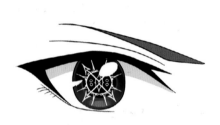

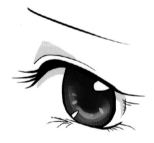

A magical symbol embedded in the eye will look impressive if symmetrical.

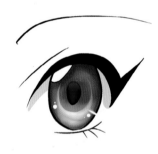

Multi-colored eyes work well for perky, magical creatures.

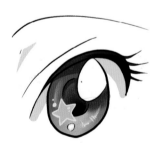

Stars or heart shapes inside the eye lend personality to cute, whimsical characters.

You can create subtle yet unique looks with various shades of eye colors.

The Mysterious Manga Eye

To give a character more of a fantasy appearance, their eyes need to tell a story. This is an eye applicable to both genders, but drawn in such a way to represent a mysterious magical creature or character.

MATERIALS

coloring tools of
your choice

eraser

paper

pencil

ruler

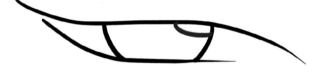

1 Draw curvy, S-shaped lines for the eyelashes.

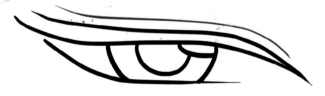

2 Draw the edges of the iris within the eye. With a squinted eye such as this one, the full circle never fits in between the lash lines.

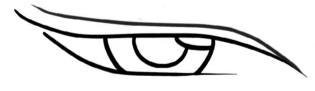

3 Draw the catch-light bubble inside the upper right area of the iris.

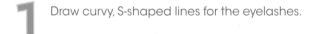

4 Draw the pupil. The pupil can have many shapes (even a V-shape for snake eyes).

5 Make the upper lash line very thick if you are going for the look of feminine eyes. Keep it a bit thinner if your character is male.

6 Add a thin parallel line above the upper lash line to give it that signature manga look.

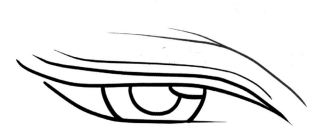

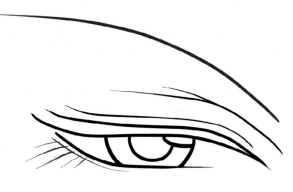

7 Draw a thin Y-shape between the eyebrow and the lash line.

8 If your character is feminine, draw thin lines under the lower lash line to add seductive lashes at the eye's edge.

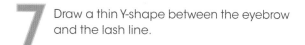

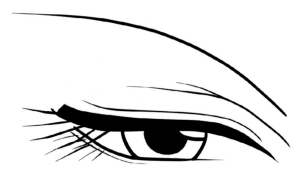

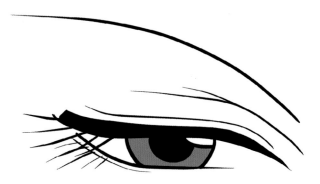

9 To give your character a dramatic look, draw in the eyebrows long and slick. Fill in the pupil and add long lashes to the upper lash line.

10 Color in the iris with a color of your choosing.

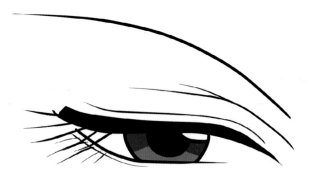

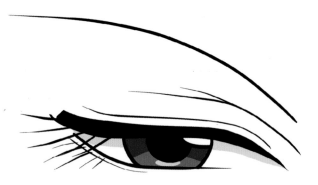

11 Add a darker shade of the same color to the upper half of the iris.

12 Complete the eye by adding a gray line along with a lighter shade of the iris color under the upper lash line.

Male Face—Front View

The following demonstrations will focus on drawing mature looking manga faces, as well as some practical tips for getting faster and better results. The shape for this type of face has an elongated look with slimmer eyes and a thinner appearance.

 MATERIALS

eraser

paper

pencil

ruler

1 Draw a circle and then split it in half vertically.

2 Place a pointed chin tip below the circle at one half of the diameter of the circle.

3 Draw two curved lines out from the circle toward the chin tip to form a chin.

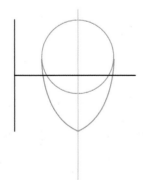

4 Split the whole face (not just the circle) in half horizontally. This is where the eyes will be positioned.

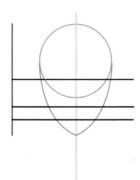

5 Split the bottom half of the face in half to get the line for placing the nose (quarter line). Split the bottom in half again to find the placement of the mouth (eighth line).

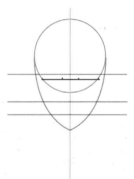

6 Divide the eye line into thirds, reserving some extra space on the outside edges of the face.

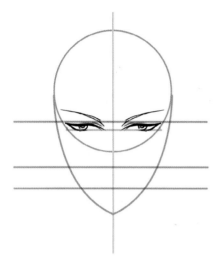 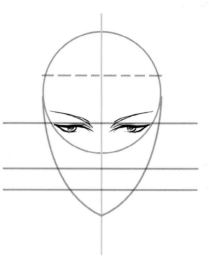 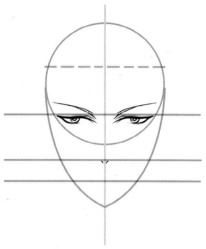

7 Draw the eyes in the outside thirds of the line. Leave the center third open. There should always be room to fit a whole eye in between the eyes.

8 To find the forehead, divide the upper half of the face. The upper quarter marks the edge of the hairline.

9 Form a nose by drawing two tiny tilted lines in the lower quarter of the face.

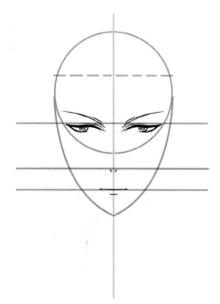 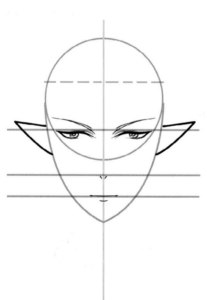 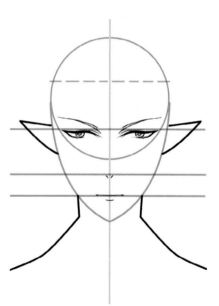

10 At the lower eighth mark of the face, draw the lips as two curvy parallel lines. For male characters lips are usually longer to create the illusion of a wider mouth.

11 Since you are going for a fantasy look here, draw elf ears by adding triangle shapes. Place them to the side between the eyebrow and nose areas.

12 Draw the neck. Male necks are about as wide as half of the head width. This may vary if the character is more skinny or muscular.

Inking

After the setup is done, there are still a few important things to do—especially when it comes to the inking part.

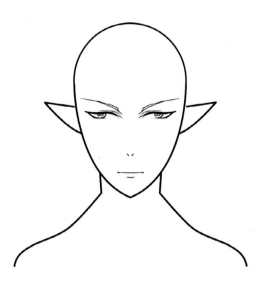

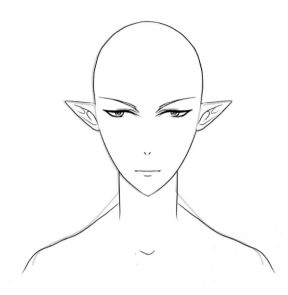

LINE THICKNESS
You can get rich line art by using lines of different thickness for different areas. For example, lines for upper eyelashes and edges of the face are generally thicker than for the rest of the details on the character.

ONE LAST LOOK
The process of inking allows a seasoned artist the chance for one last look at the sketch before placing an inked outline. Use that last look to see if maybe a new line in a perfect spot may present itself.

Shading

Manga shading is simple, but important. Here are some of the most commonly used shading patterns.

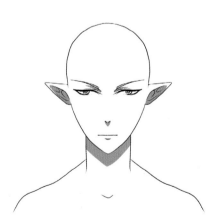

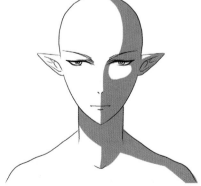

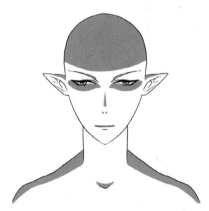

REGULAR LIGHTING
Regular lighting from above leaves shadows inside the ears, under the nose and under the chin.

SIDE LIGHTING
Side lighting makes half the head dark, except the area of the cheek.

UNDER LIGHTING
Light from underneath darkens the area under eyes, the forehead and a tiny triangle-shaped area above the nostrils.

Male Face—Side View

Now follow the steps to draw a fantasy male manga
face from a side view.

MATERIALS

eraser

paper

pencil

ruler

1 Draw a circle and then split it
in half vertically.

2 Split the circle into thirds
and make a mark one-third
of the way under the circle
to mark the chin tip.

3 Draw a straight line down
the side of the circle to be
equal with the chin tip.

4 Connect that line to the
chin mark to form the
chin shape.

5 Split the whole face (not
just the circle) in half. This
will be the line for the
eye height.

6 Split the bottom of the face
in half again. This line is the
nose base mark. The lower
eighth of the face marks
the mouth area.

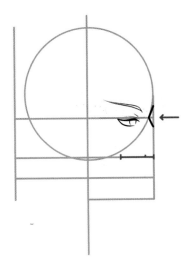
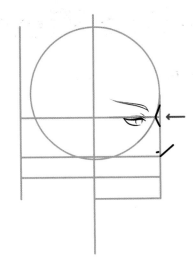
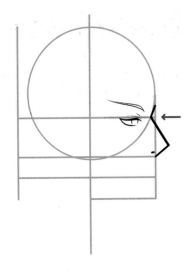

7 Follow the circle shape and make an angled, V-shaped line at the eye line to form the forehead. Draw the eye starting from the quarter of the circle width mark. The eye should not touch the nose.

8 Start the nose shape by drawing an angled line at the halfway point of the head.

9 The lower quarter of the face marks the nose base. Draw this as a tilted line and a dot with a small line as a nostril.

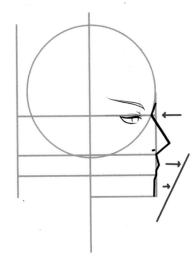
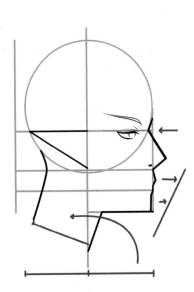

10 Keep in mind that manga faces usually have the nose as the longest feature. Fill in the upper lip, lower lip and chin tip in relative proportion to the nose. The chin tip can be drawn behind the jaw mark.

11 Draw the neck. To determine the width, use half of the circle's width as the width for the neck.

12 Connect the back of the neck to the circle at the height of the nose. Use a slightly curved line for a natural-looking neck. Draw a triangle shape to suggest elf-like ears.

Inking

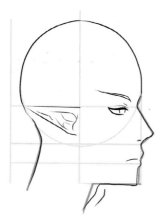

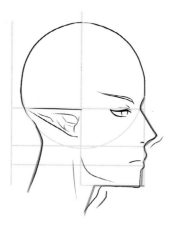

LINE THICKNESS
Play with the line thickness. Use thicker lines on the eyes and shaded areas.

A MORE REALISTIC LOOK
You can add an Adam's apple, a jaw line, a curvy nose or neck line for a more realistic style.

Trick

How to make your character look up or down:

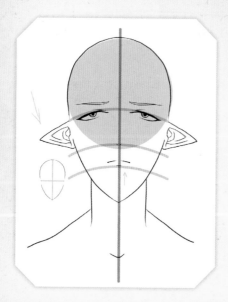

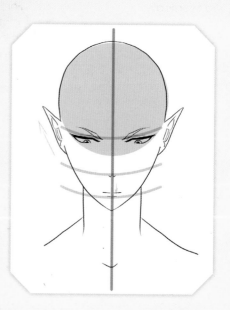

This face shape is the same as with the straight-on view face. All of the face elements (eyes, lips and nose) are moved up, and the ears are facing down.

All the face elements (eyes, lips and nose) are moved down, the ears shift and are now facing upwards.

Female Face—Front View

Now we will go through the process of creating a mysterious-looking female face by playing around with the standard face pattern to incorporate a fantasy look.

MATERIALS

eraser

paper

pencil

ruler

1 Draw a circle and then split it in half vertically.

2 Split the circle into thirds. For this face, mark off a spot a bit below one third of the circle's diameter for the chin tip.

3 Shape the jaw by drawing two curved lines from the circle edges down to the chin tip.

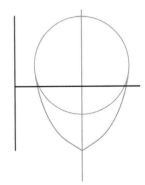

4 Split the whole face (not just the circle) in half horizontally. This is where the eyes will be positioned.

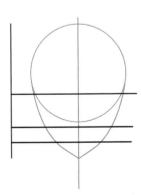

5 Split the bottom half of the face in half to get the line for placing the nose (quarter line). Split the bottom in half again to find the placement of the mouth (eighth line).

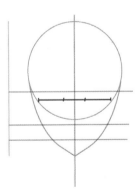

6 Divide the eye line into thirds, reserving some extra space on the outside edges of the face.

27

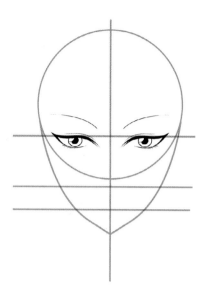

7 To achieve the look of a dreamy or mysterious character, draw the eyes under the mid-point line. Be sure to keep one eye width in between them. Add thin arched eyebrows just above.

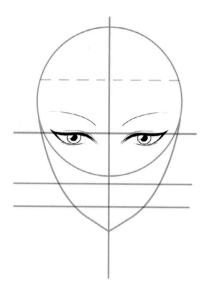

8 Mark off the edge of the hairline in the upper quarter of the head.

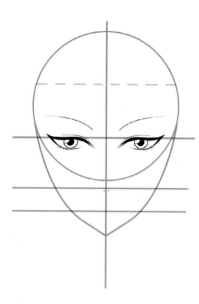

9 Form the nose by drawing two thin tilted lines near the lower quarter line of the face.

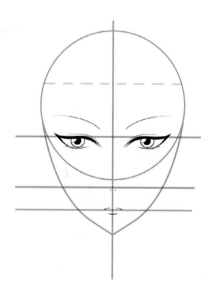

10 Place the mouth halfway between the nose and the chin. Try experimenting with the placement by drawing it a bit higher or lower, depending on your style.

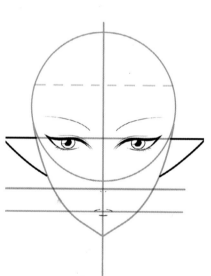

11 Draw elf ears by adding triangle shapes. Place them to the side between the eyebrow and nose areas.

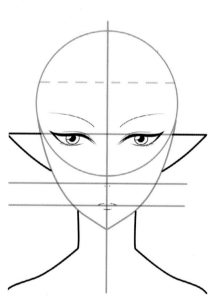

12 Add the neck. The female neck can be narrow or wide depending on the body shape; however, it should always be half the width of the head.

Inking

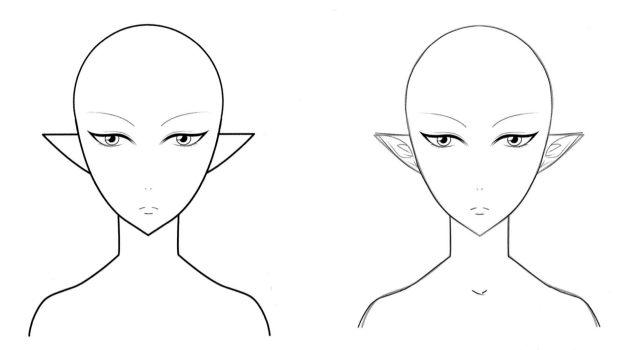

FOR BEST RESULTS
To get the best results while inking your works, test out different line thicknesses and use your last look at your pencil sketch to visualize where you should place the ink lines. Sometimes the lines of your sketches will not match the final inked lines, and that's OK. It is all a part of the art-making process.

Shading

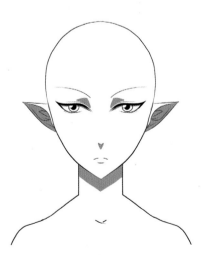 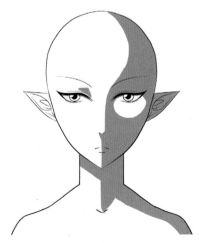

REGULAR LIGHTING
Shading for normal daytime light shows in the form of shadows inside the ears, under the chin and on the nose and eyebrows.

SIDE LIGHTING
Side lighting throws all the shading on one side of the face, opposite the light source.

UNDER LIGHTING
Under light is good for scary effects. It shows shadows on top of the nose, cheeks, eyelids and forehead.

Female Face—Side View

This time we are creating a mature, more realistic female face, so some details will be different from the standard doll-style female manga face.

MATERIALS

eraser

paper

pencil

ruler

1 Draw a circle and then split it in half vertically.

2 Split the circle into thirds and make a mark one-third of the way under the circle to mark the chin tip.

3 Draw a straight line down the side of the circle to be equal with the chin tip.

4 Connect that line to the chin mark to form the chin shape.

5 Split the whole face (not just the circle) in half. This will be the line for the eye height.

6 Split the bottom of the face in half again. This line is the nose base mark. The lower eighth of the face marks the mouth area.

 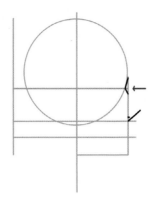 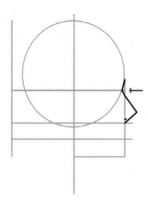

7 Follow the circle shape and make an angled, V-shaped line at the eye line to form the forehead.

8 Start the nose shape by drawing an angled line at the halfway point of the head.

9 Draw a line to connect the base to the top of the nose.

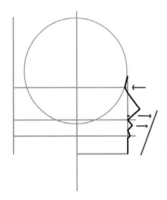 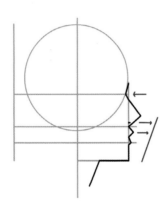 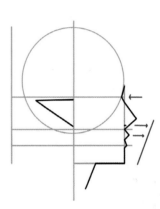

10 As you draw in the lips, remember that the nose is the longest feature. Next longest is the upper lip, then the lower lip and finally, the chin.

11 To start the neck, draw a tilted line halfway from the chin to the middle line.

12 Form elf ears by drawing triangle shapes located between the height of the eye and the nose.

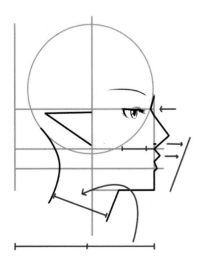

13 Draw the eye and eyebrow and finish the neck. The eye should not touch the edge of the face. It usually has a triangle shape when seen from the side. As a more mature female, this character should have a neck width close to half of the circle's width.

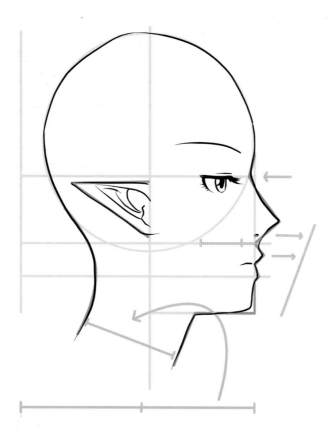

LINE THICKNESS
Even when the positioning is done, the drawing is not finished. Inking with lines of different thickness is the key to a successful look.

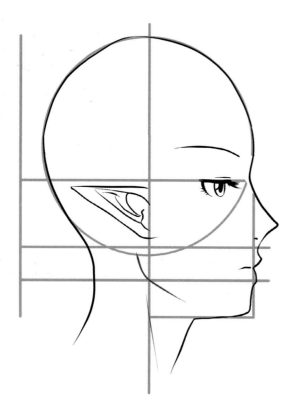

A MORE REALISTIC LOOK
If you add lines for the jaw and neck muscles, you will get a less elegant but more realistic-looking character. Changing details can change the style significantly.

Changing Elements

Now keep the same base, but try changing the elements of the face (eyes, ears, nose and chin shape). You will get a whole new character each time.

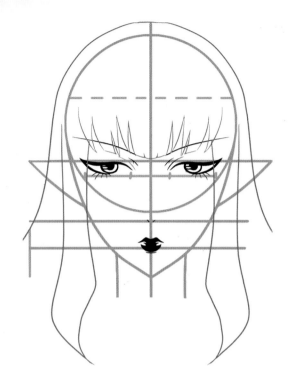

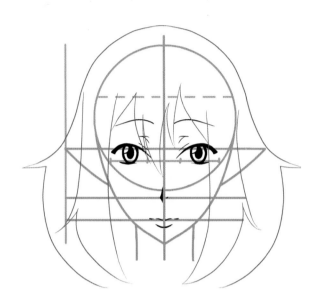

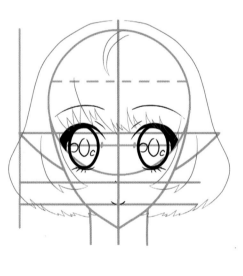

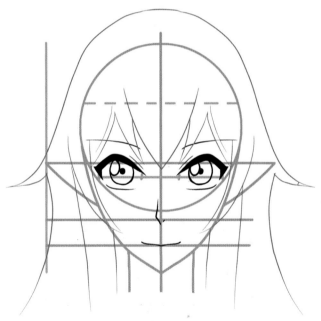

ON STYLE

When you know the basics, you can master any manga style. If you feel you wish to draw it, just go for it. You don't have to limit your art to only one style.

THERE IS A WHOLE RAINBOW OF MANGA STYLES!

BODY PROPORTIONS—COUNTING HEADS

The height of a single head can be used to measure the overall height of your manga characters. It will also help you to make a character's hands, feet and limbs the appropriate size. Adding or subtracting heads will create different heights and relative proportions in a character. In a fantasy world, various heights can be combined with different body types to create everything from human-like to extreme fantasy characters.

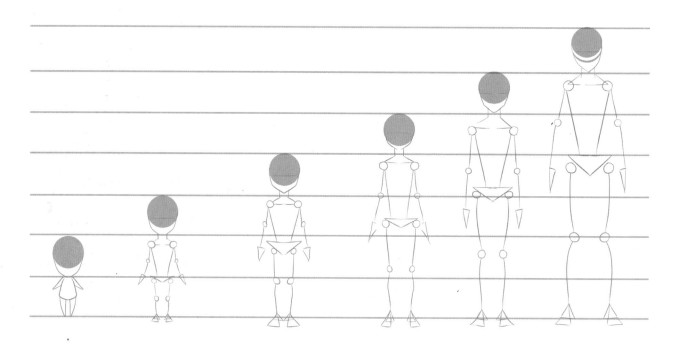

For most body shapes, the legs will start near the body's halfway point, no matter what the height.

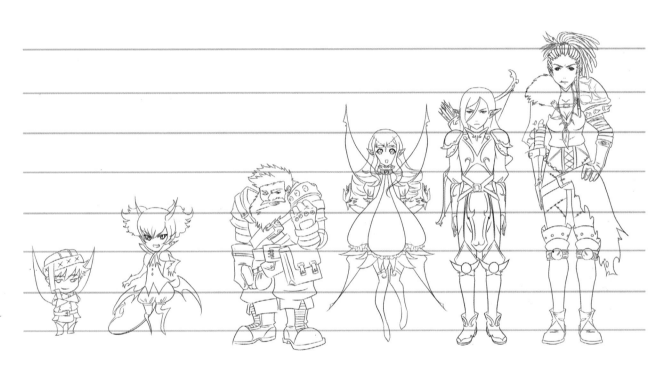

Chibi bodies are usually two heads tall. Here the chibi body was used to create a pixie character.

A height of three heads makes a nice imp character.

This muscly body type was combined with a height of four heads to create a dwarf.

Five heads were used to create the height for this fairy.

This elf has a lean body type and is six heads tall.

At seven heads tall, this half orc is about the same size as a human.

MALE BODY SHAPES

In fantasy manga, a typical male protagonist has a body that is seven heads tall. In this book we will focus more on body shape than height. The trick to manga aesthetics is understanding why the body has its shape, and then drawing only the most necessary lines in the finished artwork.

Remembering the proportions of the body is the first step, but shaping the body to look appealing is the bulk of the process. It is mastered by repetition and practice.

Young Male Character

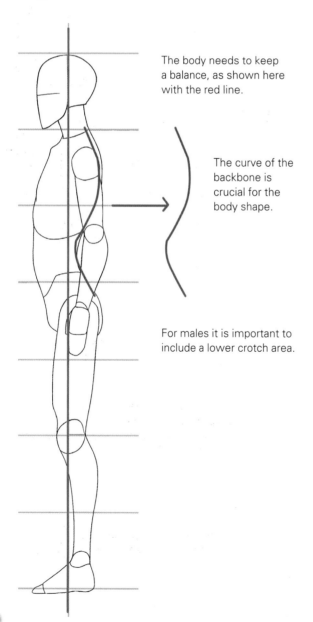

The body needs to keep a balance, as shown here with the red line.

The curve of the backbone is crucial for the body shape.

For males it is important to include a lower crotch area.

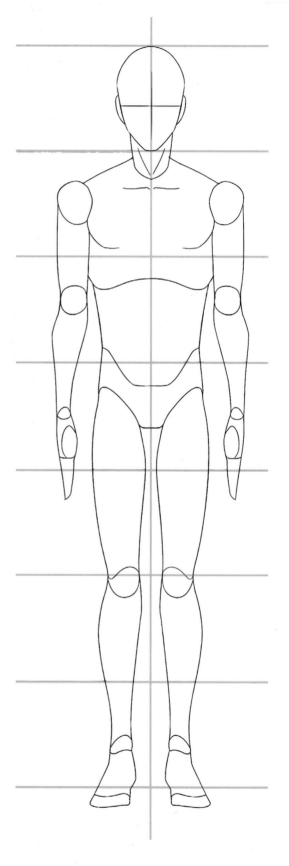

Shaping a character like a robot or a doll helps you envision the potential movement.

For a better understanding of body shapes, practice sketching live models and models in photos. Drawing real people will help you store important shapes in your memory so you can apply them to manga characters later.

There are many possible body shapes for human and humanoid characters; they can be skinny, chubby or muscular. Below are just a few.

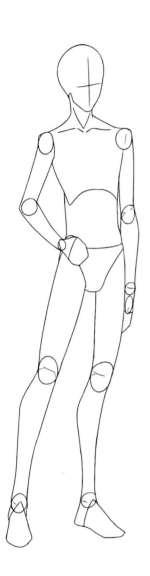

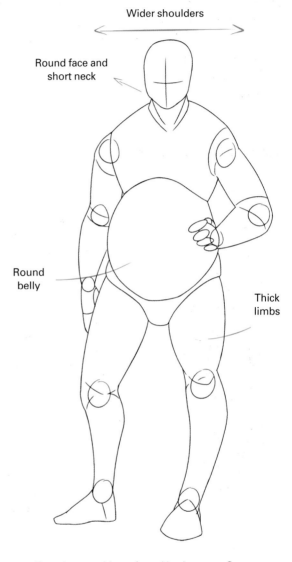

Wider shoulders

Round face and short neck

Round belly

Thick limbs

Skinny characters have thin limbs.

Muscular characters have thick necks.

Experiment with preferred body types. Some body types can suit your characters and creatures more than others. It just depends on your personal aesthetics.

The shoulder-waist-hip ratio can be changed to get different torso shapes.

Mature Male Character

Mature and adult characters usually appear taller and have a height of seven or eight heads and even more. Besides height, for a more developed character it is very important to pay attention to the main lines that form the muscles and general torso shape. Here we will focus on a traditional muscly, handsome figure.

Wider shoulders compared to the waist create a more developed figure.

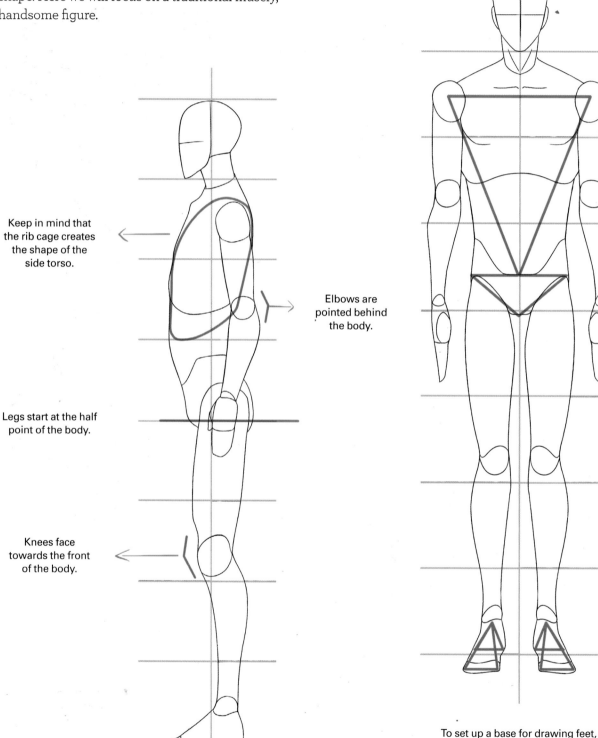

Keep in mind that the rib cage creates the shape of the side torso.

Elbows are pointed behind the body.

Legs start at the half point of the body.

Knees face towards the front of the body.

To set up a base for drawing feet, draw two connected triangles.

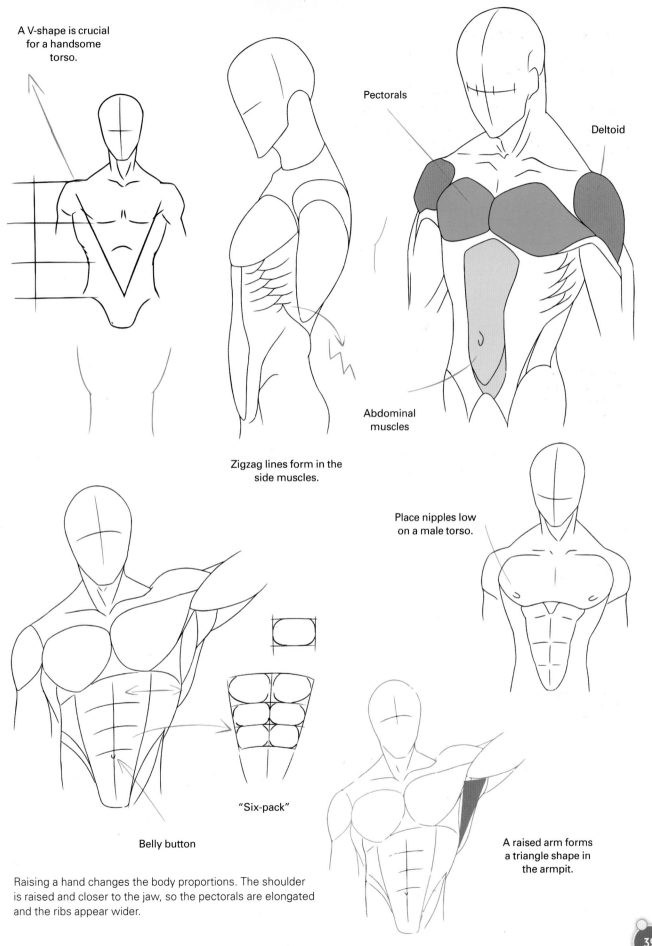

A V-shape is crucial for a handsome torso.

Pectorals

Deltoid

Abdominal muscles

Zigzag lines form in the side muscles.

Place nipples low on a male torso.

"Six-pack"

Belly button

A raised arm forms a triangle shape in the armpit.

Raising a hand changes the body proportions. The shoulder is raised and closer to the jaw, so the pectorals are elongated and the ribs appear wider.

39

FEMALE BODY SHAPES

When a character is six heads tall, it can be youthful or already a fully developed adult character. This height is a standard for females in manga, but many other characters depicting youth can have these same proportions.

Many artists have problems drawing both genders and shaping both types of bodies. This is mainly because the torso of a female has inverted proportions to the male torso—a female's hips are the widest part of the torso, instead of the shoulders.

Young Female Character

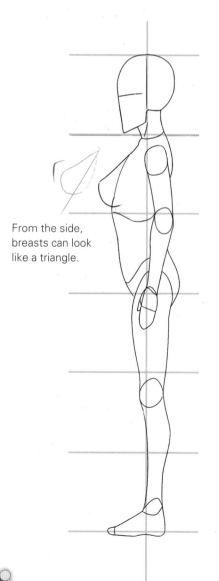

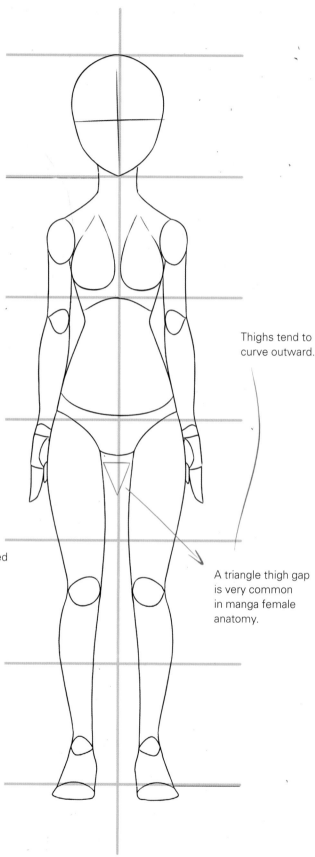

To draw breasts from the side, it is very important to draw the rib cage first.

From the side, breasts can look like a triangle.

Since female hips are wide set, the inner thigh gap is prominent, but usually exaggerated in manga.

Thighs tend to curve outward.

A triangle thigh gap is very common in manga female anatomy.

Muscles and fat are distributed differently in everyone, so always use photo references and observe people around you to become familiar with different body shapes. There are so many beautiful body types out there. Here are just few.

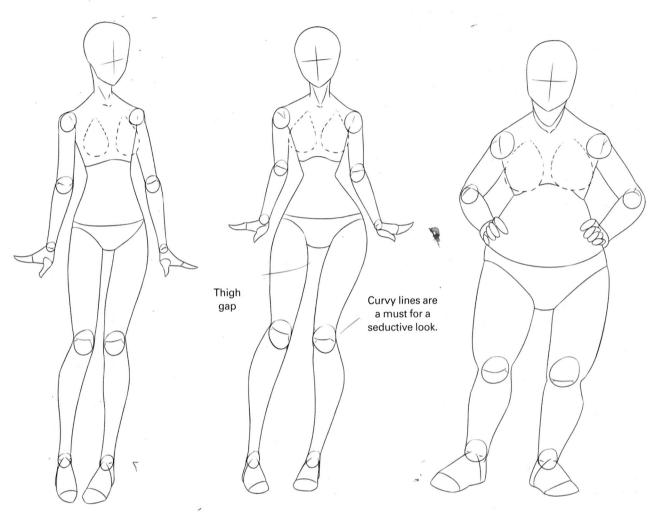

Thigh gap

Curvy lines are a must for a seductive look.

Slim figures work well when drawing elves' bodies.

Any body type can be combined with any breast size.

Voluptuous figures can be applied to drawing strong warrior characters.

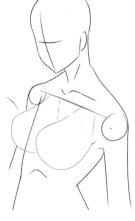

Imagine water balloons on a string.

The shoulder-waist-hip ratio determines different shapes for the torso, making the body types different.

Mature Female Character

Mature and tall female characters in anime and manga usually have a height up to seven heads. There is more than one way to spread the body proportions across this height. For example, some artists may choose to place both the torso and head within the first three heads. This results in a character that has long slender legs.

Making elongated proportions is a personal preference and usually used for very stylized characters. It is important to remember that a balanced body has the legs starting in the middle.

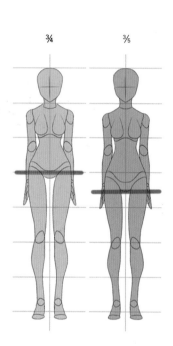

Both of these proportions are correct because, just as with real people, not everyone has the same body shape.

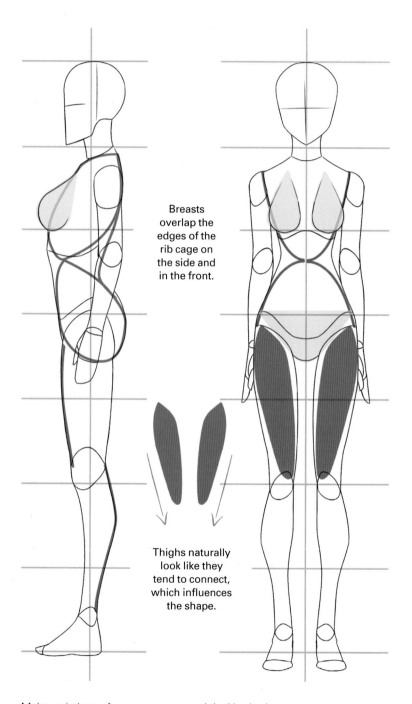

Breasts overlap the edges of the rib cage on the side and in the front.

Thighs naturally look like they tend to connect, which influences the shape.

Make variations of your own to get original body shapes. Breaking the mold can be a good thing.

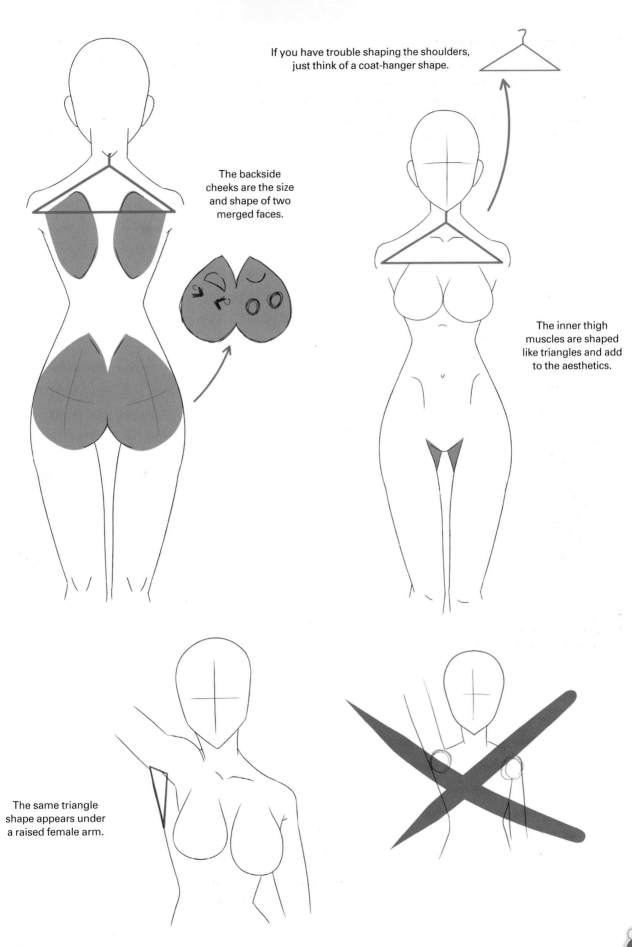

If you have trouble shaping the shoulders, just think of a coat-hanger shape.

The backside cheeks are the size and shape of two merged faces.

The inner thigh muscles are shaped like triangles and add to the aesthetics.

The same triangle shape appears under a raised female arm.

COUNTER POSES

Every movement contains a counter pose. It's how the body keeps its balance.

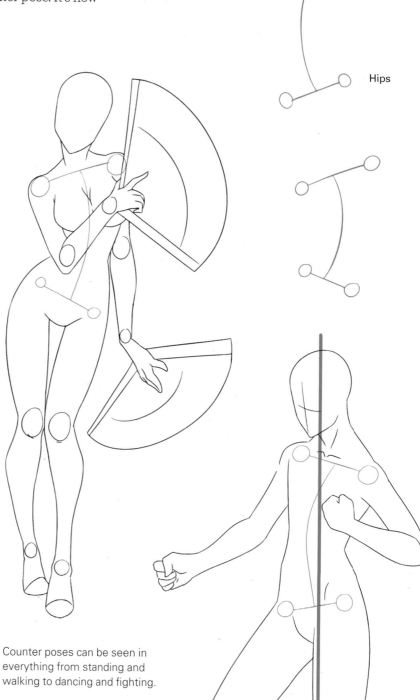

Shoulders

Hips

Counter poses can be seen in everything from standing and walking to dancing and fighting.

In counter poses, the shoulders and hips are usually tilted to the opposite side.

Even in counter poses, the body needs to follow an imagined straight line. This ensures that every pose is stable and prevents the figure from appearing to fall or tilt.

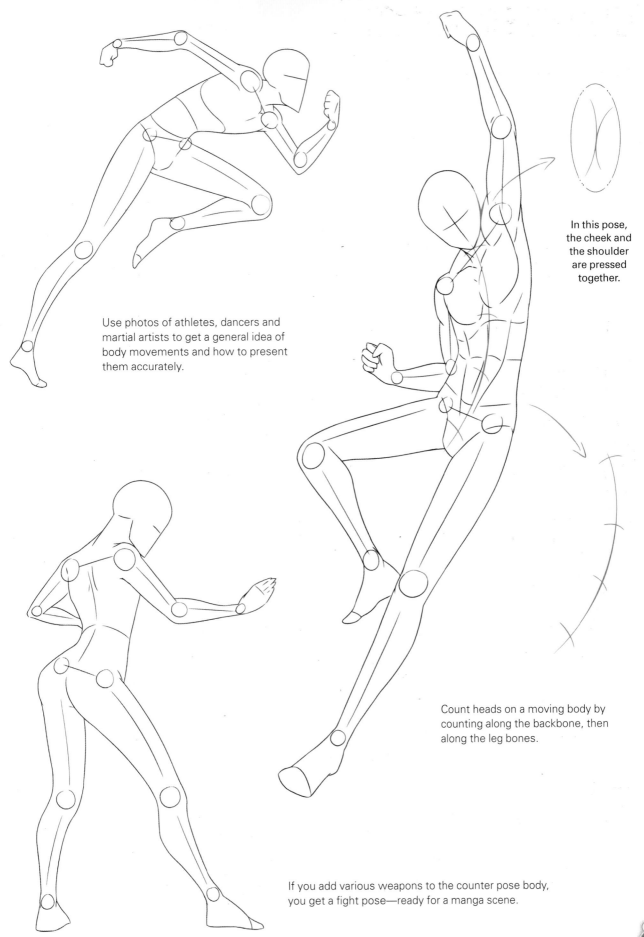

Use photos of athletes, dancers and martial artists to get a general idea of body movements and how to present them accurately.

In this pose, the cheek and the shoulder are pressed together.

Count heads on a moving body by counting along the backbone, then along the leg bones.

If you add various weapons to the counter pose body, you get a fight pose—ready for a manga scene.

FORESHORTENING

When body parts overlap and certain parts are closer to the eye of the beholder, those parts should be drawn enlarged. And while these parts are enlarged, other parts appear as shrunken or shortened.

Here we have an easy foreshortening example of a normal body with enlarged hands. The best way to determine how much to enlarge a hand is to research photo and live references.

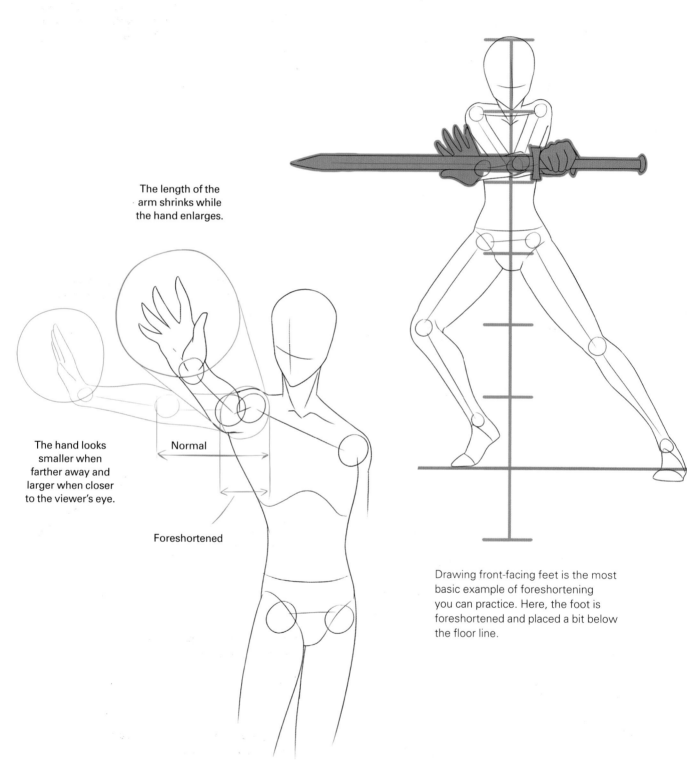

The length of the arm shrinks while the hand enlarges.

The hand looks smaller when farther away and larger when closer to the viewer's eye.

Normal

Foreshortened

Drawing front-facing feet is the most basic example of foreshortening you can practice. Here, the foot is foreshortened and placed a bit below the floor line.

Worm's-eye view　　**Bird's-eye view**　　**Front view**

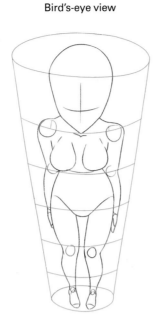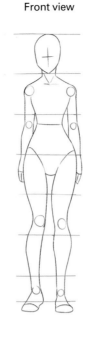

Imagining poses from different perspectives is not easy. You can use 3-D models, photo references and modeling puppets for poses of this level of difficulty. (Note that the neck is not visible in the bird's-eye view.)

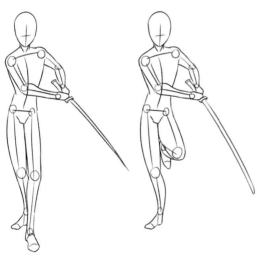

Take a sword pose and lift one knee to get a running pose. Shorten the blade to make it look like it's behind the figure.

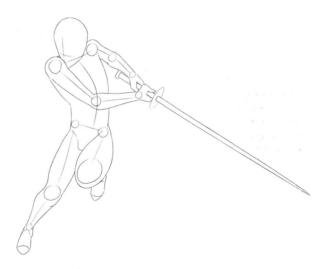

Make the pose look like a bird's-eye view by enlarging the head and making the feet smaller.

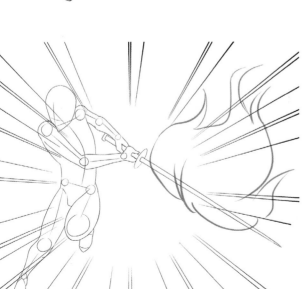

To turn this pose into a cool scene, add some speed lines and magic flames—voilá!

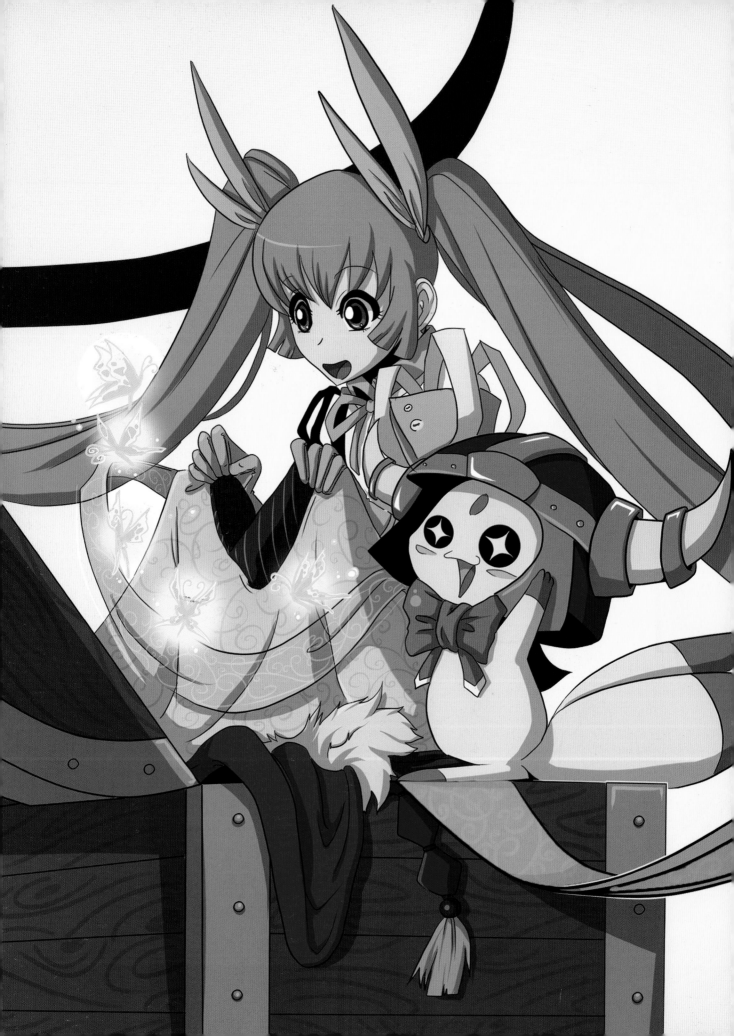

3

Details

Adding cool clothes, hairstyles, accessories and weapons to your characters will make them look original and appealing— not to mention believable. This chapter will cover everything you need to know about designing different styles and accessories to enhance your manga fantasy characters and creatures.

HAIR STYLES

Fantasy gives you an excuse to have all kinds of fun with your characters' hair—from making it defy gravity to glowing like a rainbow. These are just few examples, combined with some accessories and fantasy eye styles we explored in the last chapter.

Red hair can be a symbol of a fire-powered character.

Buns and flowing ribbons can be used for cute characters.

Sometimes just a vibrant hair color will do.

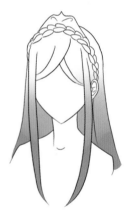

One or more colored hair parts can tell a story.

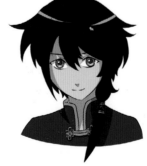

Braids and loose ponytails work well for adventurers.

Hair with a gradient can symbolize a magical ability.

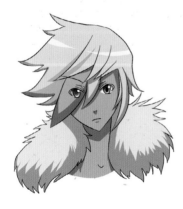

FEMALE HAIR

Female hair can sometimes be spiky in shape, but usually has more of a flow. Longer haircuts can feature various bang shapes, braids, ponytails, pigtails or curls.

Braids can be drawn as stacked ovals or little hearts.

Locks are formed out of cylinders, then connected and covered with hair.

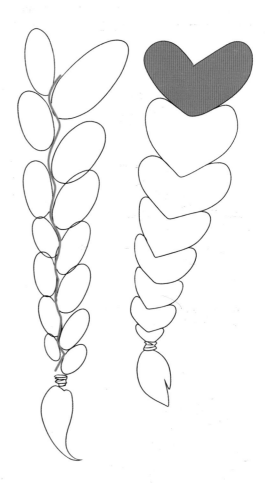

In manga, hair is drawn as several hair strands bunched together, rather than drawing each individual strand of hair.

A zigzag hairline is advisable when the hair is pulled back. And don't forget: girls have sideburns, too. They should be visible when the hair is up.

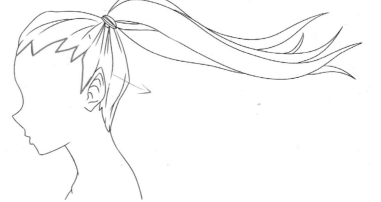

MALE HAIR & FACIAL HAIR

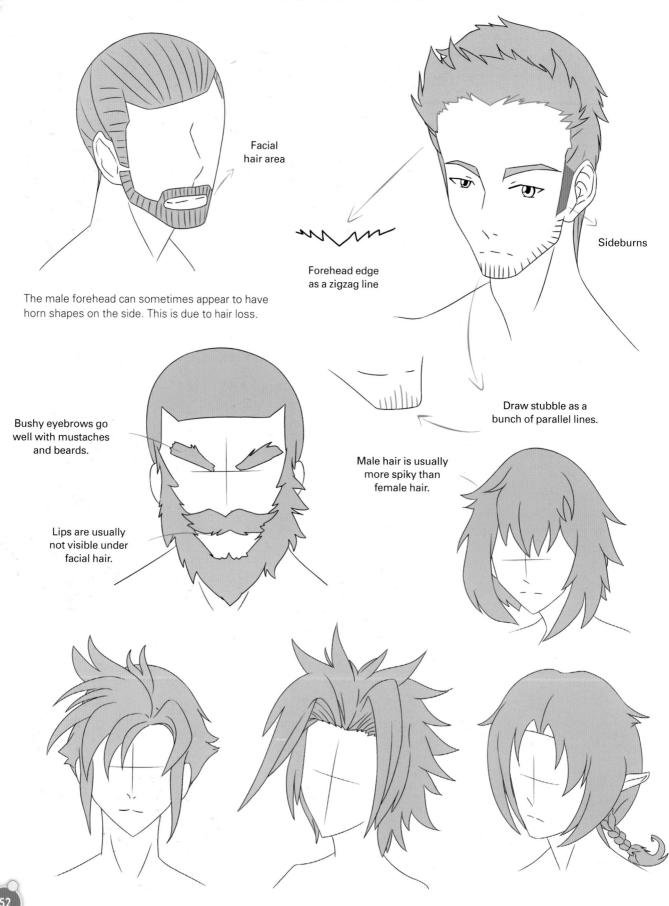

Facial hair area

Forehead edge as a zigzag line

Sideburns

The male forehead can sometimes appear to have horn shapes on the side. This is due to hair loss.

Draw stubble as a bunch of parallel lines.

Bushy eyebrows go well with mustaches and beards.

Male hair is usually more spiky than female hair.

Lips are usually not visible under facial hair.

ACCESSORIES

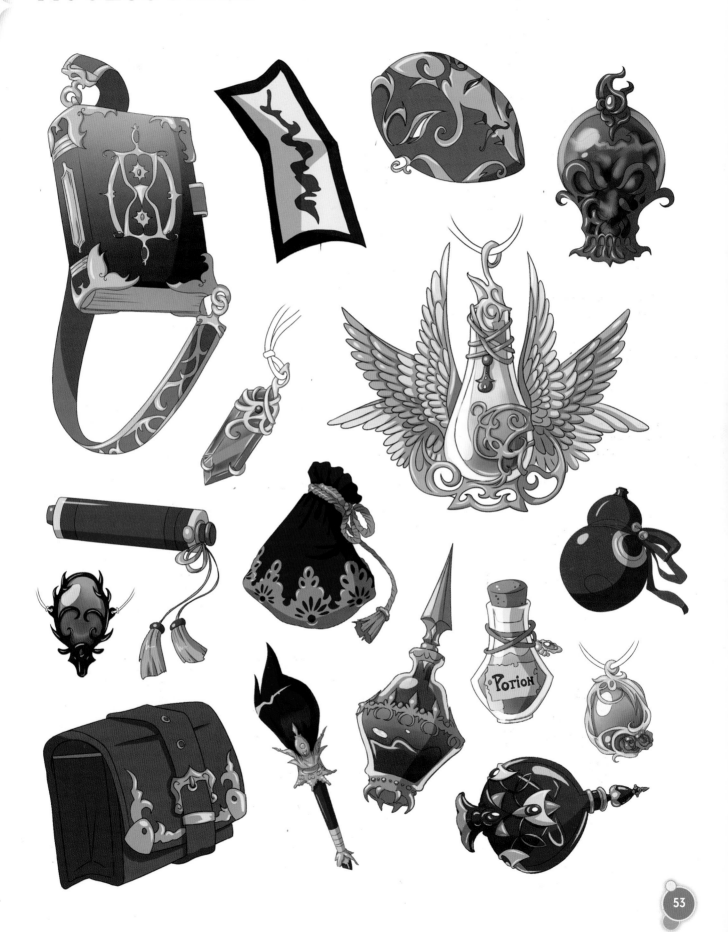

Draw Accessories

The most common items in any fantasy manga are a scroll, which can be a letter or important news, and a generic amulet—worn on anything from an enchanted sword, a sorceress book or a nobleman's cravat.

MATERIALS

coloring tools of your choice

eraser

paper

pencil

Scroll

1 Draw a spiral shape. Add two curvy parallel lines.

2 Close the shape. Add a small parallel line to the spiral.

3 Add shaded areas and ragged edges to create the look and feel of old paper. Add a seal and ribbon for a royal look. A wax seal usually has a circle with a symbol and a wavy wax edge.

Amulet

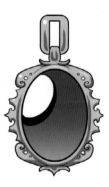

1 Start with an oval shape. Draw an oval catch-light bubble in the upper left area of the oval. Give the catch-light a shadow edge.

2 Add a gradient color of your choice over the surface. Use curvy lines around the edges of the oval to plan out a frame.

3 Draw the frame. A symmetrical shape for frames works well for fantasy pendants. Add a key chain extension for a realistic look.

EMBLEMS

Emblems can be worn on cloaks and clothes, or may appear on shields, banners or castles. They hold a very important link to your manga story. Elements of a coat of arms are actually made after a set of rules called heraldry. We will use these rules and some symbols from history to create our own unique coat of arms!

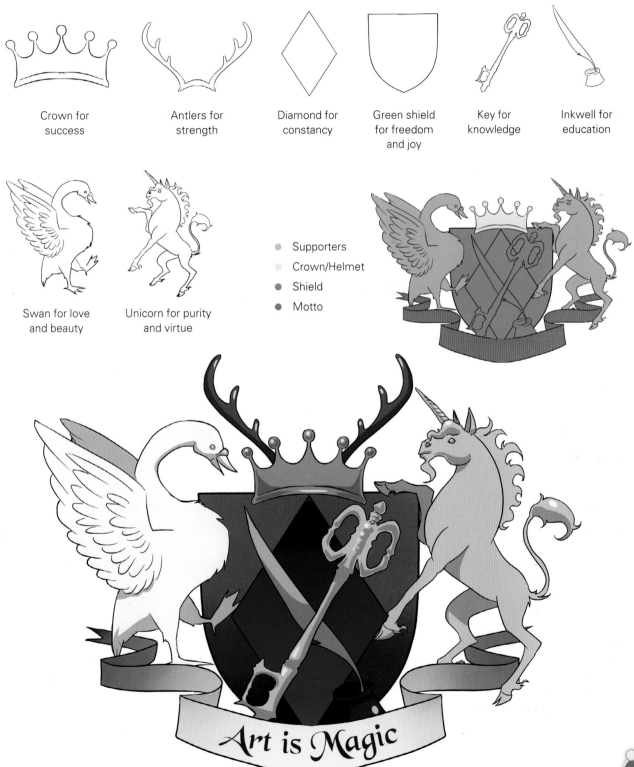

Crown for success

Antlers for strength

Diamond for constancy

Green shield for freedom and joy

Key for knowledge

Inkwell for education

Swan for love and beauty

Unicorn for purity and virtue

- Supporters
- Crown/Helmet
- Shield
- Motto

Art is Magic

RIDING GEAR

Drawing your own riding gear is another way to give a personal touch to your fantasy worlds and manga stories. Riding gear is comprised of a system of belts and buckles. Cart-pulling systems can be applied to any land animal. Try to re-imagine your own animal characters with riding gear and pull systems.

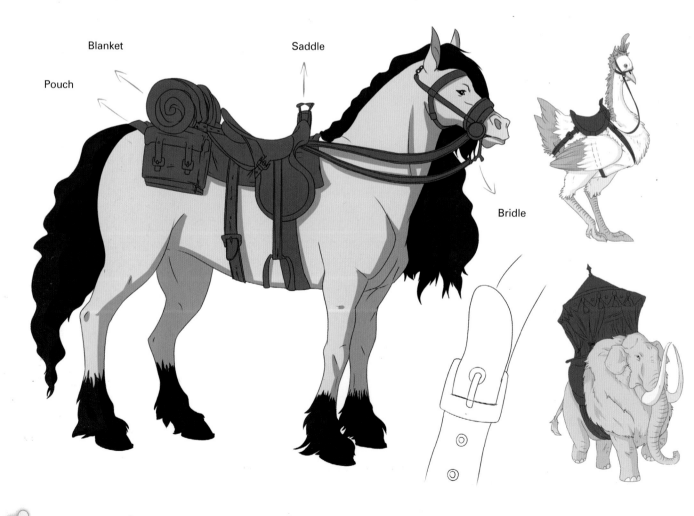

Blanket

Saddle

Pouch

Bridle

WEAPONS & HANDS

Fantasy anime and manga characters are seen wearing
gloves almost all the time. Whether these are leather or
fabric gloves, they come in two main shapes: fingerless and
full. Just like in clothes, the glove adds volume to the hand,
contains seam lines and has creases on the main finger joints.

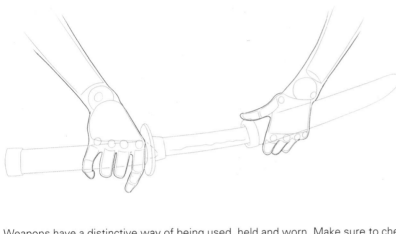

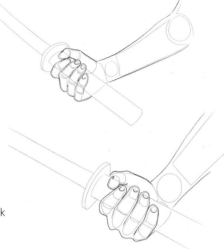

Weapons have a distinctive way of being used, held and worn. Make sure to check
your photo references beforehand for the best results in fight scenes.

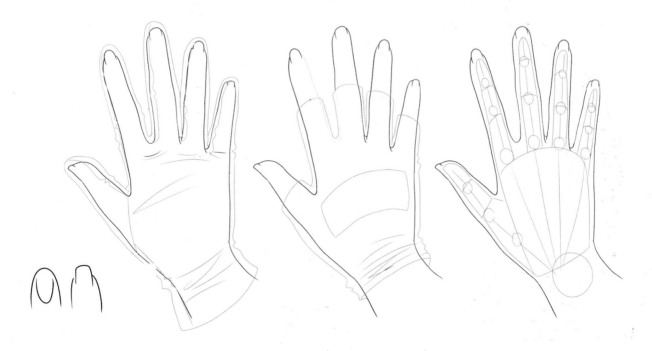

Make sure to plan out the nail shape. Use a U-shaped nail for a masculine hand and
an elongated nail shape for a feminine look.

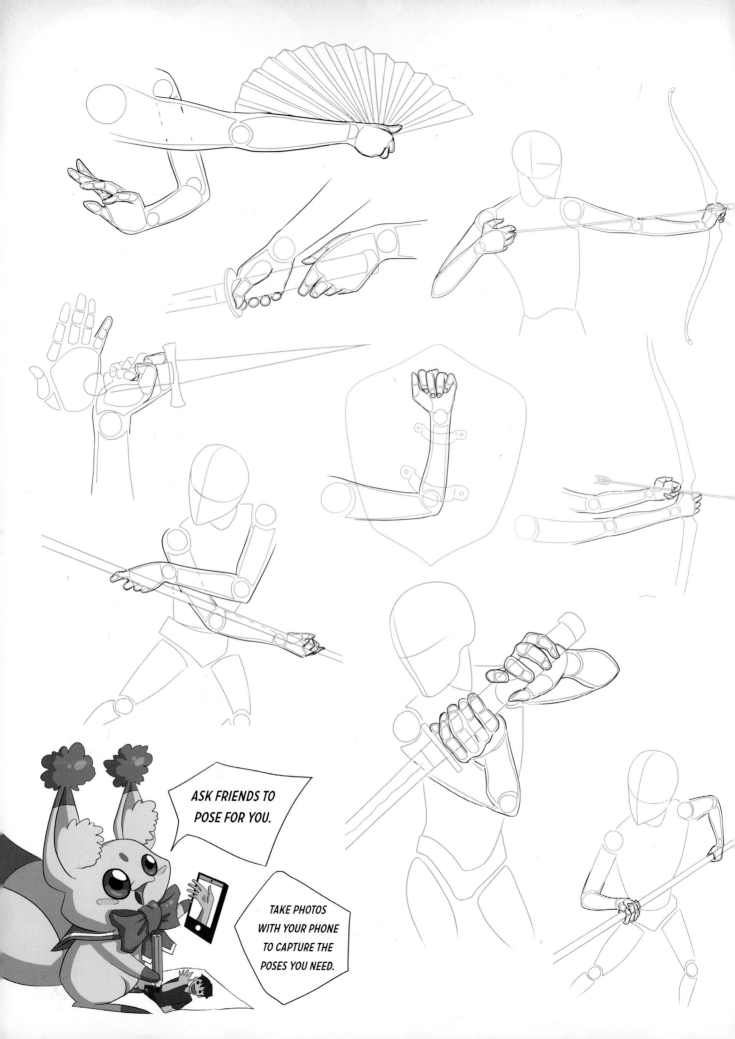

ASK FRIENDS TO POSE FOR YOU.

TAKE PHOTOS WITH YOUR PHONE TO CAPTURE THE POSES YOU NEED.

POSES WITH WEAPONS

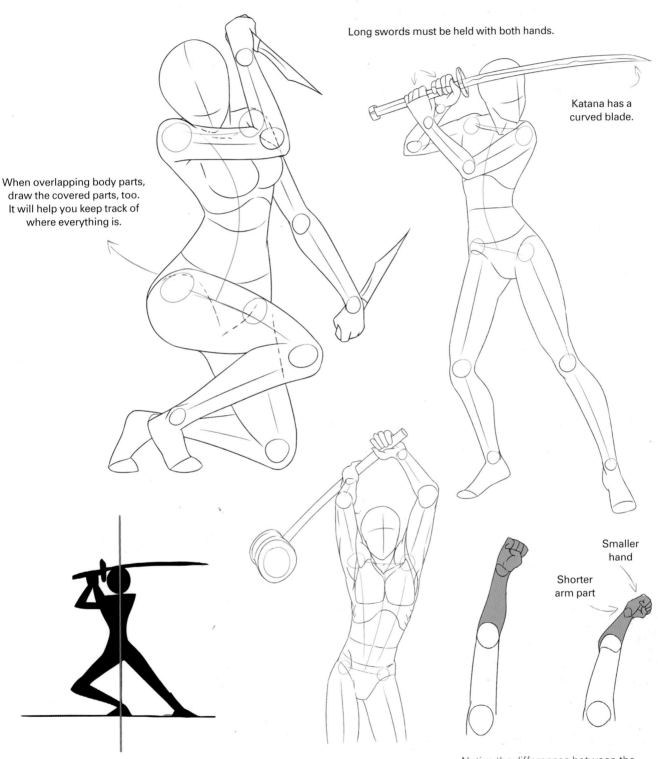

Long swords must be held with both hands.

Katana has a curved blade.

When overlapping body parts, draw the covered parts, too. It will help you keep track of where everything is.

Smaller hand

Shorter arm part

Make sure the main body axis makes a straight angle with the floor.

Limbs going behind the body look shorter or smaller due to foreshortening. This effect makes your pose look more 3D and creates dynamic results.

Notice the differences between the foreshortened arm on the right and the regular arm on the left.

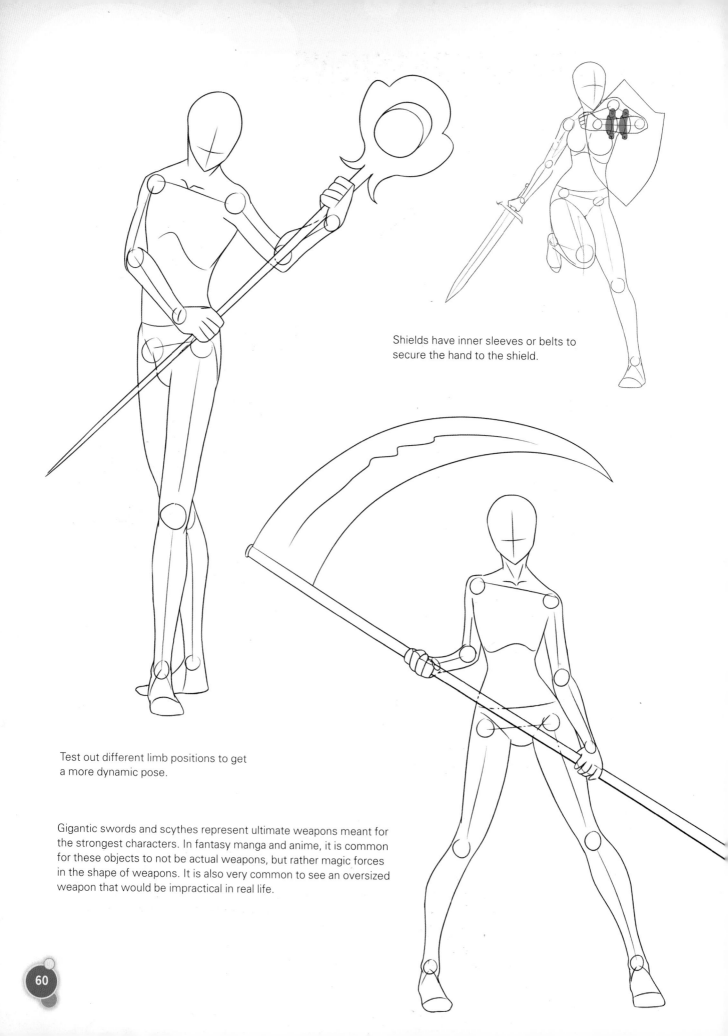

Shields have inner sleeves or belts to secure the hand to the shield.

Test out different limb positions to get a more dynamic pose.

Gigantic swords and scythes represent ultimate weapons meant for the strongest characters. In fantasy manga and anime, it is common for these objects to not be actual weapons, but rather magic forces in the shape of weapons. It is also very common to see an oversized weapon that would be impractical in real life.

COUNTER EXPRESSIONS

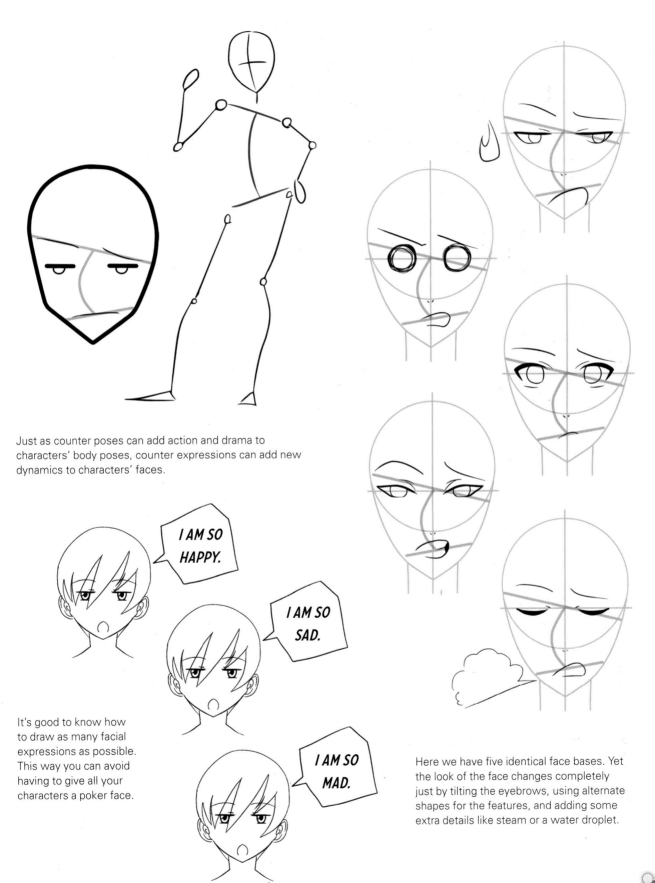

Just as counter poses can add action and drama to characters' body poses, counter expressions can add new dynamics to characters' faces.

I AM SO HAPPY.

I AM SO SAD.

I AM SO MAD.

It's good to know how to draw as many facial expressions as possible. This way you can avoid having to give all your characters a poker face.

Here we have five identical face bases. Yet the look of the face changes completely just by tilting the eyebrows, using alternate shapes for the features, and adding some extra details like steam or a water droplet.

CLOTHING

It is important to first draw the body before starting the clothes. Keep in mind that clothes crease in areas where the body bends—shoulders, elbows, waist, hips and knees.

When drawing frills, make a swirly zigzag line, then connect it to the upper line.

Volume goes for shapes as well.

Clothes always add volume, so don't worry that your character will be too wide because you've added clothes. It take years to develop a solid understanding of how to draw draped fabric. Practice by using reference photos.

Fashion Details

Modern details like zippers and belts are always acceptable. Anime fashion in fantasy can mix anything you like, as long as it's well incorporated into the design.

Lace is one of the most used elements in fantasy fashion. It is based on one repeating decorative pattern. It is often seen on the hems of dresses, but it can appear elsewhere. Here we have examples of both plain and complicated patterns, as well as lace attached to a hem to form a frill.

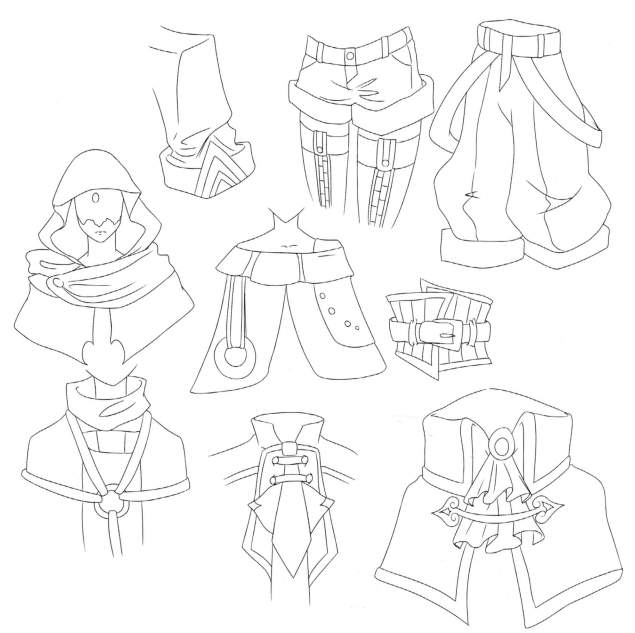

Historical & Cultural Clothing

Anime aesthetics often combines similar shapes and takes inspiration from cultural and historical clothing from both Western and Eastern cultures.

General shapes and details from various cultures or eras are re-imagined to dress up characters in a fantasy world. Here are some of the most commonly used styles for fantasy anime and manga clothing.

Medieval clothing

Renaissance clothing

Victorian Era clothing

Modern high school uniform

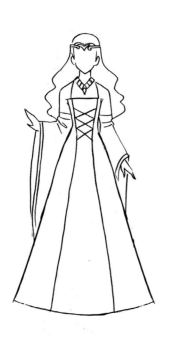

Chinese Hanfu

Chinese cheongsam

Japanese miko (priestess) clothing

Japanese geisha clothing

While female fantasy clothes are based on pretty or elegant fashions, male fantasy clothing is based more on warrior and ruler uniforms and armor.

Medieval armor

18th-century French military uniform

World War II military uniform

19th-century clothing

Modern Asian high school uniform

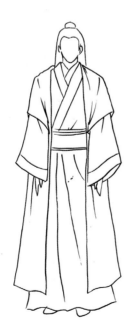

Chinese Hanfu

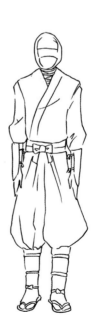

Japanese ninja clothing

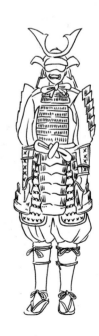

Japanese samurai armor

You will frequently see historic and modern styles of clothing combined in fantasy fashion. The look is even more dramatic when weapons are added.

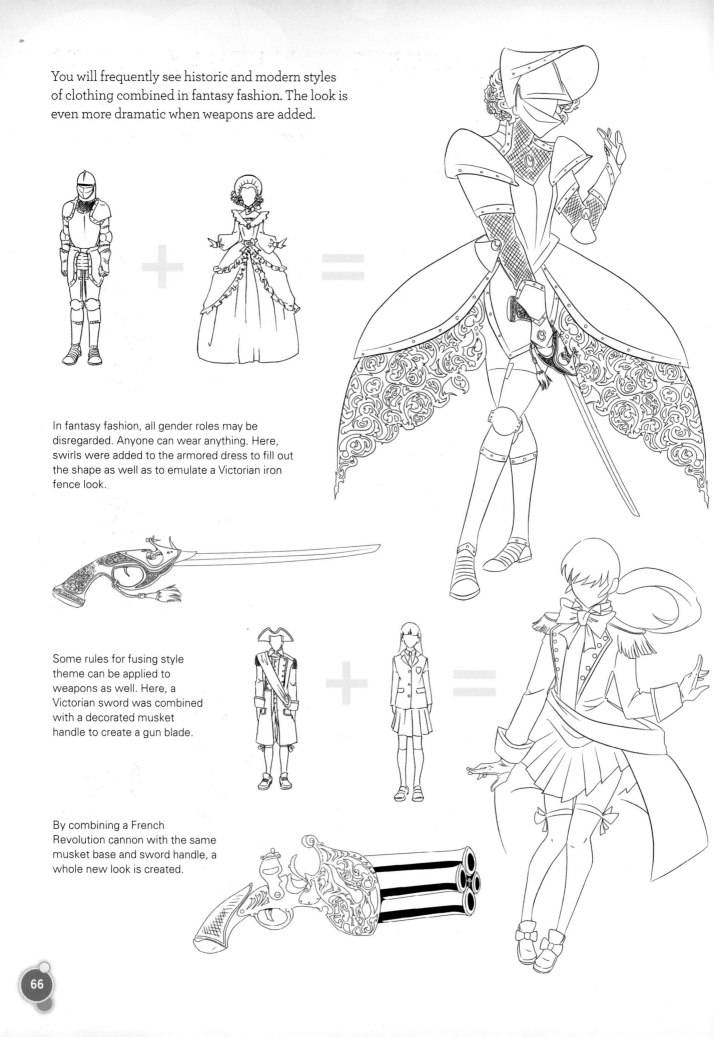

In fantasy fashion, all gender roles may be disregarded. Anyone can wear anything. Here, swirls were added to the armored dress to fill out the shape as well as to emulate a Victorian iron fence look.

Some rules for fusing style theme can be applied to weapons as well. Here, a Victorian sword was combined with a decorated musket handle to create a gun blade.

By combining a French Revolution cannon with the same musket base and sword handle, a whole new look is created.

CREATING CONCEPTS FROM SILHOUETTES

Silhouettes are shapes that tell us about the character before we have even seen the details. Professional artists use silhouettes to design clothing, characters and creatures. Following are some of the most commonly used silhouettes. You can build on these or come up with new designs of your own.

Adventurer silhouettes have:
- Prominent gloves
- Big feet
- Lots of belts

The marked thigh area is iconic in the design of manga characters.

Seductress/Villain silhouettes have:
- Curvy body shapes
- High gloves
- Thigh-high stockings
- High heels for an elongated figure

Yellow marks the most prominent areas of the silhouettes.

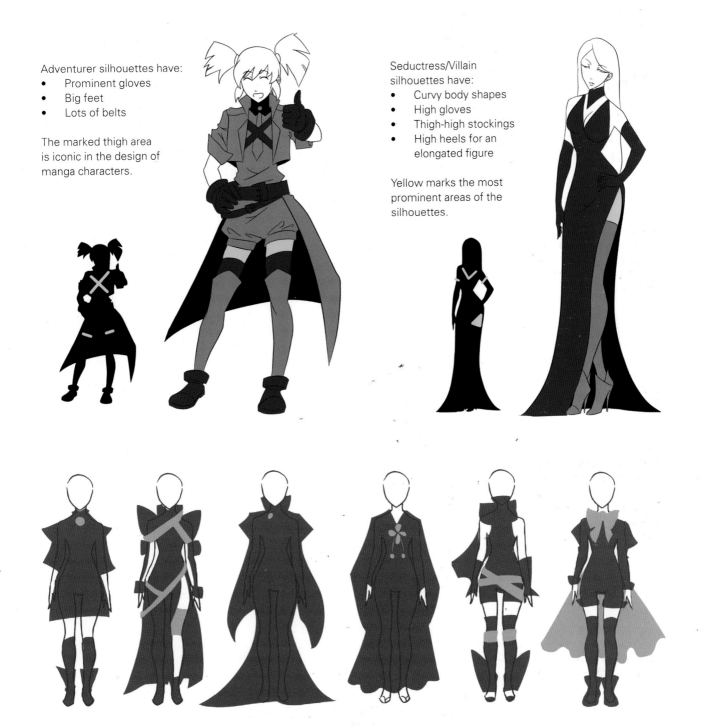

Try creating some of your own designs from these silhouettes.

Most male silhouettes are based on symmetry to represent power. They feature a lot of crossed shapes and details like oversized belts and zippers.

Many male fantasy clothes are high-waisted, and it is common to see male characters in knee- or thigh-high boots.

Adventurer silhouettes have:
- Big gloves
- Chunky shoes
- Lots of belts

Placing X shapes adds to the adventurous feel of the design.

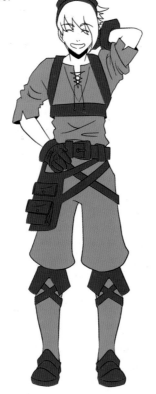

Villain/Ruler silhouettes have:
- Horned crown/head shape
- Big shoulders
- Long cape or loincloth
- Mostly symmetrical design

Yellow marks the most prominent areas of the silhouettes.

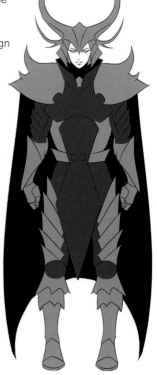

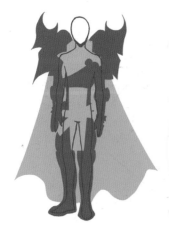

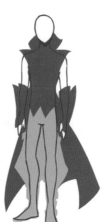
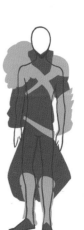
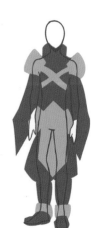

Try creating some of your own designs from these silhouettes.

MAPPING OUT YOUR FANTASY WORLD

You can map out your manga fantasy world any way you like. Perhaps your new world is organized into territories by race or ethnicity. Or maybe it's divided into climate zones. It's all up to you, and the possibilities are endless!

It all begins with a little split tea, coffee or paint. Then a few dabs here and there and lots of imagination… and voilà—you have a new fantasy world for your manga story!

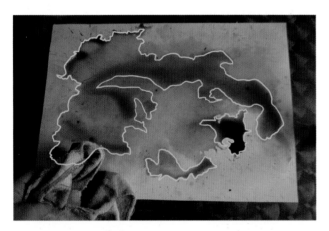

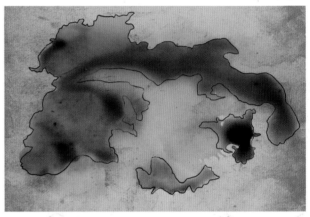

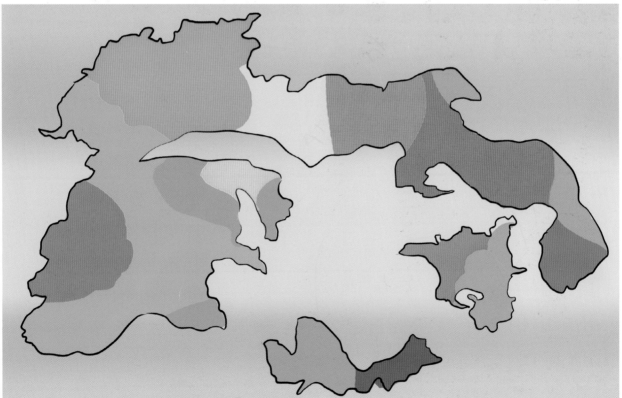

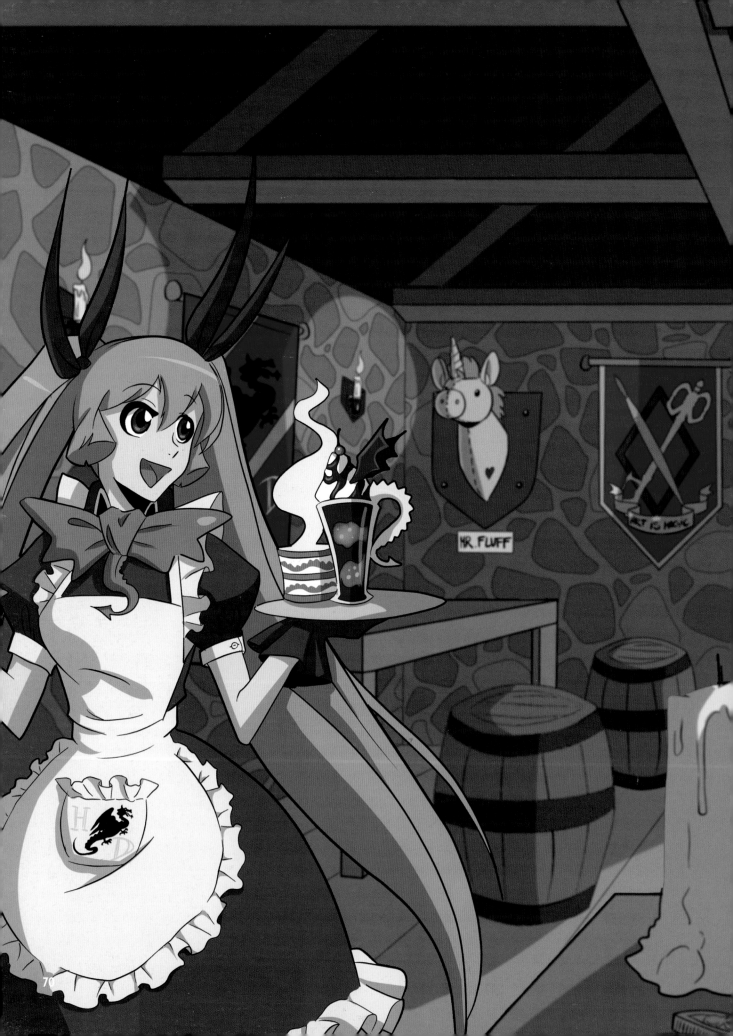

4

PUTTING IT ALL
Together

By now you should have a solid foundation in both the basics as well as adding details. So let's put that knowledge to use creating your own complete fantasy manga stories and characters. In this chapter, I will give you tips for creating dynamic exciting compositions and show you how to pull everything you have learned together into unique fantasy manga scenes.

FANTASY CREATURE INSPIRATION

Inspiration for creating fantasy creatures can be drawn from legends from all over the world, from characters in fairy tales, and by re-imagining human and animal forms into something new. These creatures can represent emotions or nature, or they could symbolize entire cultures. Here are just few of the most commonly known fantasy creatures.

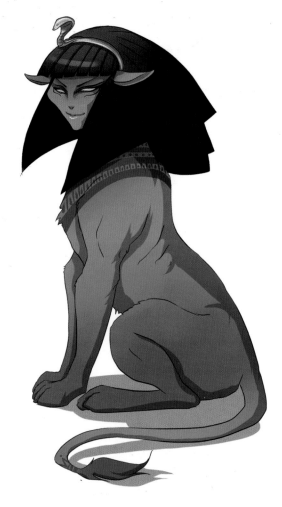

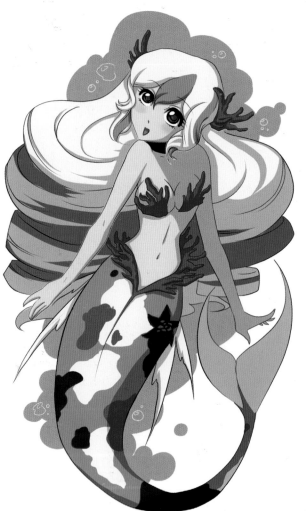

The Sphinx has the body of a lion and a head of a human. This treacherous creature is said to eat anyone who fails to answer her riddle.

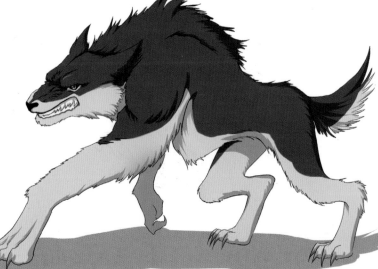

Mermaids are half-human and half-fish. They are the main characters in many sailor stories. This particular design was inspired by Japanese koi.

Werewolves are huge wolf-like creatures. In their beast form, they represent pure rage.

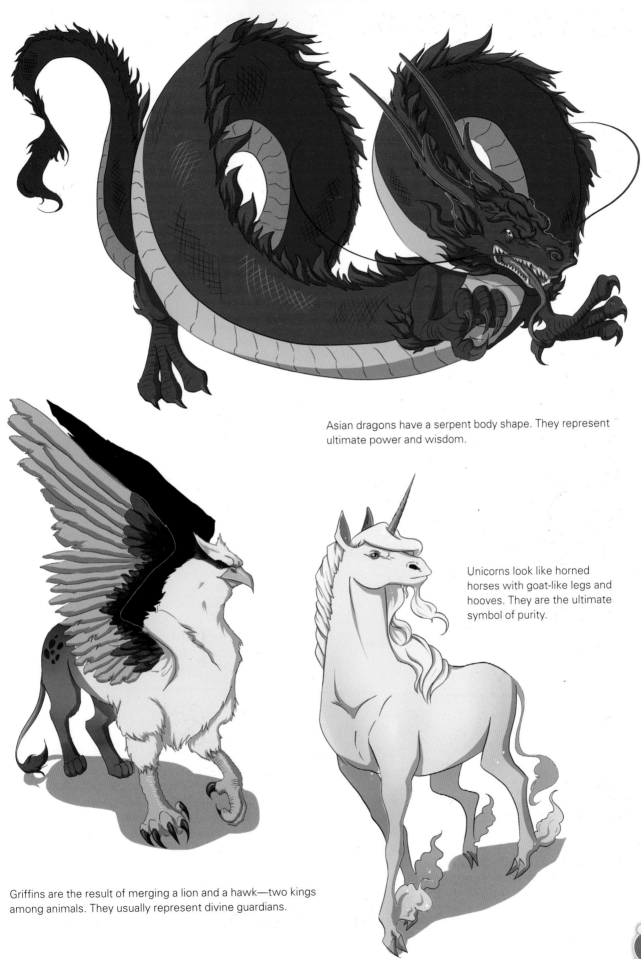

Asian dragons have a serpent body shape. They represent ultimate power and wisdom.

Unicorns look like horned horses with goat-like legs and hooves. They are the ultimate symbol of purity.

Griffins are the result of merging a lion and a hawk—two kings among animals. They usually represent divine guardians.

DESIGNING UNIQUE FANTASY CREATURES

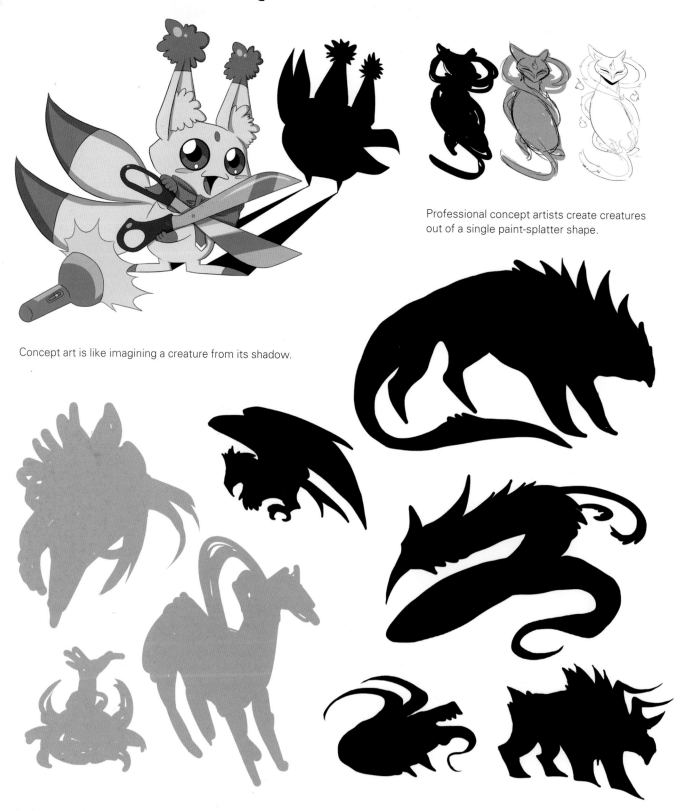

Concept art is like imagining a creature from its shadow.

Professional concept artists create creatures out of a single paint-splatter shape.

Let's try to re-imagine a splatter as different creatures. Try out some of these shapes to create whole new creatures.

You can also create fantasy creatures out of more defined silhouettes.

Animal Details

In manga, regular animals are drawn realistically. These are just a handful of the realistic animal bases that can be used to create your fantasy manga creatures.

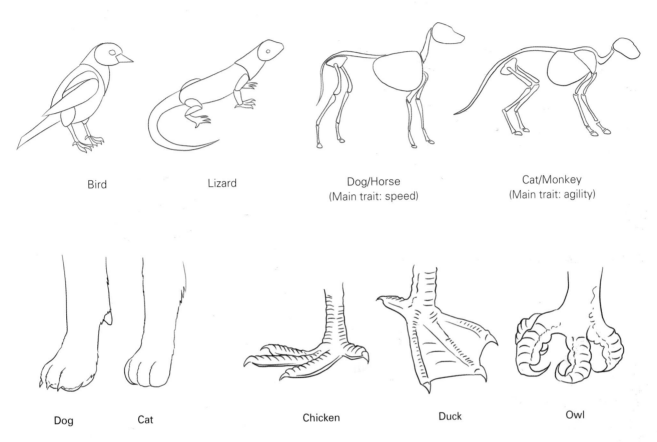

Bird

Lizard

Dog/Horse
(Main trait: speed)

Cat/Monkey
(Main trait: agility)

Dog

Cat

Chicken

Duck

Owl

Observe how feet can be used to represent the creature's lifestyle.

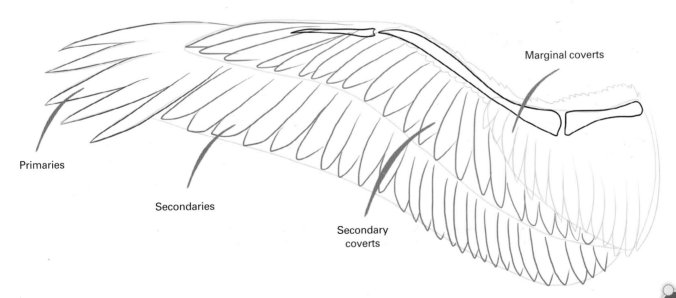

Marginal coverts

Primaries

Secondaries

Secondary coverts

Merging Animal Shapes

The process of merging aspects of various realistic animals in order to create a unique fantasy creature is based on the careful positioning of the animal parts.

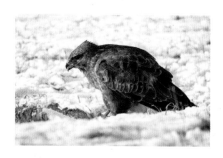 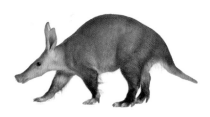 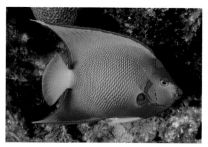

As inspiration for our new fantasy creature, we will use the features and characteristics of three different animals: a buzzard (feathers), an aardvark (fur) and an angel fish (scales).

Choose your parts carefully if you want to avoid a comic-book effect. Do not just cut and paste pieces together.

In a successful creature design, body parts are merged together smoothly.

Blending different animals together can be a gateway into blending various original animal colors into one design. Of course, this is just an artistic suggestion. You can chose any color palette you like.

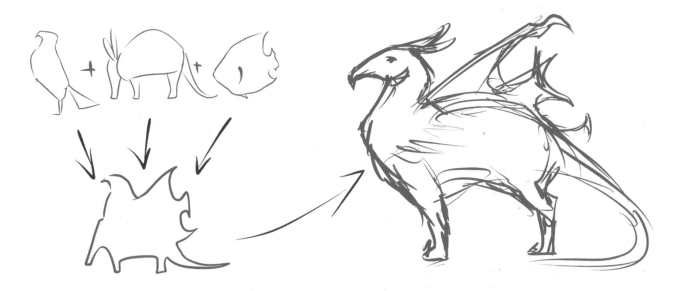

Try to imagine a sculpture made out of various animals shapes. Then shape them all together into one cohesive creature.

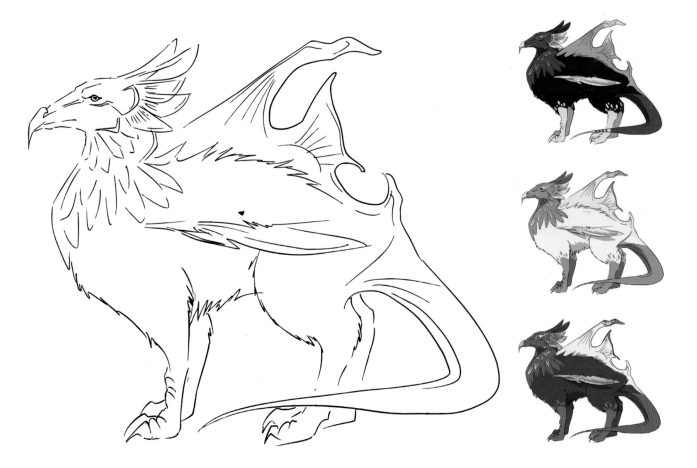

The art of filling in a silhouette with details takes repetition, practice and a lot of patience. The same goes for picking the perfect color palette. Don't be afraid to experiment until you've got it right.

HUMANIZING YOUR FANTASY CREATURES

Now let's mix in some human features to turn this fantasy creature into a fantasy character. You can experiment by taking different human silhouettes and incorporating various textures. This method works great for designing both humanoid characters and costumes.

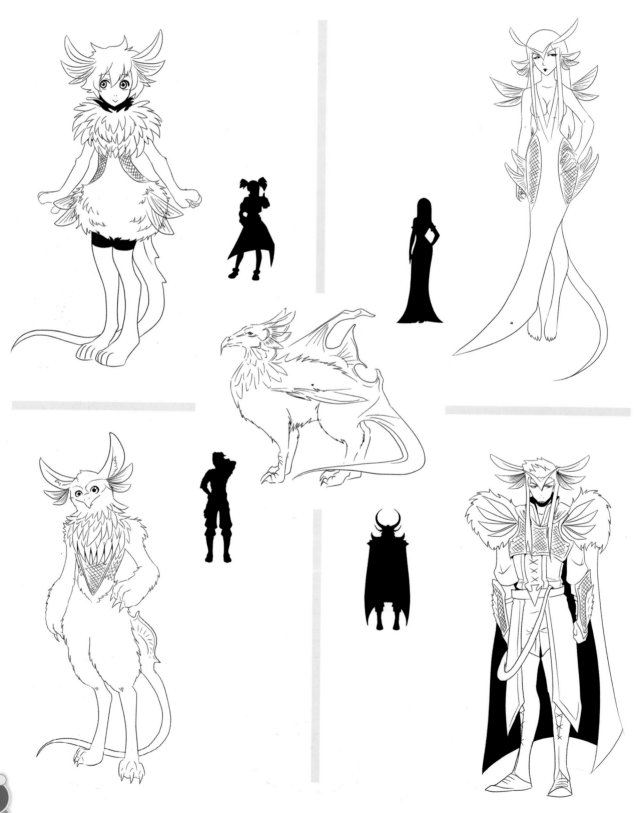

REFINING YOUR DESIGN CONCEPTS

When you get to the stage of the design process that involves tweaking and refining your fantasy creatures and characters, try to imagine how they would evolve naturally. By multiplying textures and other small elements, you can elevate your design. At this point, it's best to focus more on small details rather than larger elements like the limbs or head.

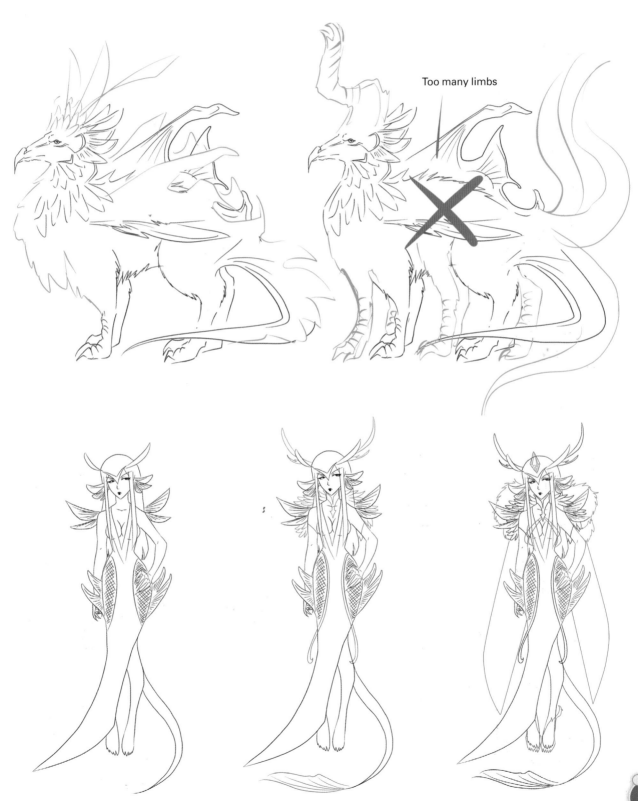

Too many limbs

FANTASY MANGA MASCOTS

Mascots are often charming, quirky creatures that can inject a bit of comedy into almost any fantasy manga story.

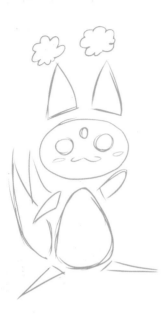

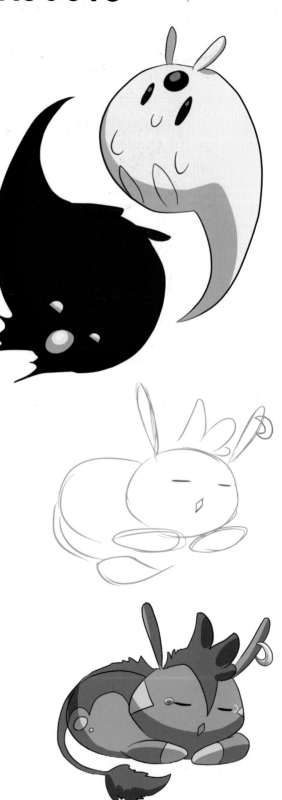

Can you guess who was made from this collection of simple shapes?

Sometimes eliminating certain facial features, like the nose and using simple shapes, like the shape of the number 3; or the letter U, can make the mascot creature even cuter.

Don't overdo details; simplicity is king.

Design Fantasy Mascots

Mascots are inspired by real animals, geometric shapes, and even inanimate objects. They are usually based on a single simple shape like an egg, circle or curvy amoebic shape.

Follow the steps to draw these fantasy manga mascots. Then try mixing up and combining different shapes and parts of animals to create a unique mascot of your own.

MATERIALS

coloring tools of your choice

eraser

paper

pencil

1 Shape the base, then use more simple shapes to add the facial features.

2 Add an accessory, such as a hat, bow or scarf.

3 Finalize the details and ink it. Then color it in.

Design a Fantasy Setting

Follow the steps to design and illustrate a room for a manga fantasy setting.

 MATERIALS

coloring tools of your choice

eraser

paper

pencil

1 Determine the horizon line. In reality, the horizon is where the land (or sea) and sky meet. In drawing perspective, it's the level your eyes are at, an imaginary line to where our view recedes. Usually it is placed near the middle of the scene, but it can be a bit above or below.

2 Mark a disappearing point. This is the point from which all the objects and walls will be drawn. If you place it off center on the horizon, you'll get a more dynamic picture.

3 Draw a rectangle near the middle of the scene. This will mark the outline of the room.

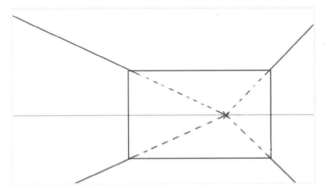

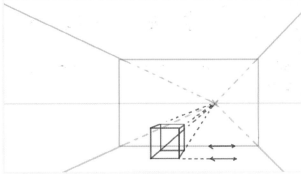

4 Now form a room by drawing lines from the disappearing point through the edges of the rectangle. Then erase the lines inside the rectangle.

5 To place an object inside the room, draw a small square. Then draw lines through the edges. All vertical lines should be parallel to the edge of the original rectangle.

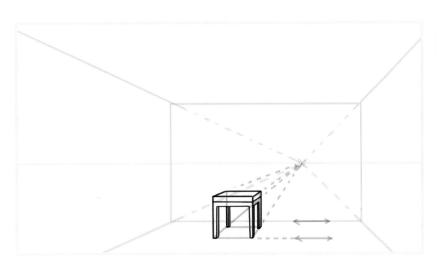

6 Now you have a cube, which can be a base for almost any object. It can be drawn into a piece of furniture, such as a table. (Square objects are easier to draw than curvy ones.)

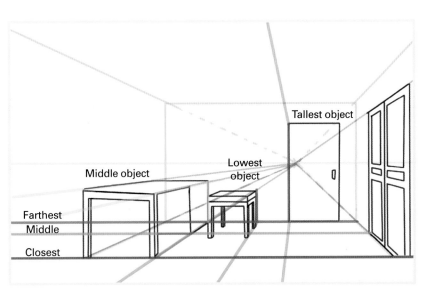

Tallest object

Lowest object

Middle object

Farthest
Middle
Closest

7 Add more objects to the room. It is necessary to pay attention to the distance between the objects. If you mark the height and distance from the main wall (where the door is drawn), you can't go wrong.

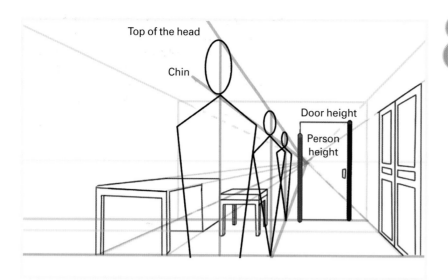

Top of the head

Chin

Door height

Person height

8 Add people into the room using the same rules you applied for adding furniture. It is imperative to pay attention to the person's height and distance from the main wall. The height of the person is shown on the main wall, compared to the door height, marked in blue.

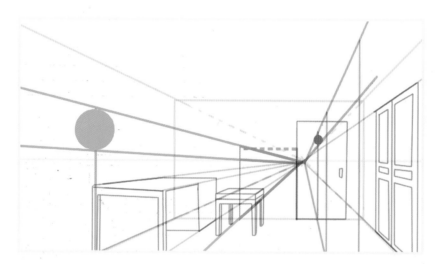

9 Place people at certain spots in the room. Place a shorter person where the green height lines indicate, then place a taller person just inside the door where the purple height lines indicate. By using the disappearing point, you can place your characters anywhere along these lines to make your scene appear different.

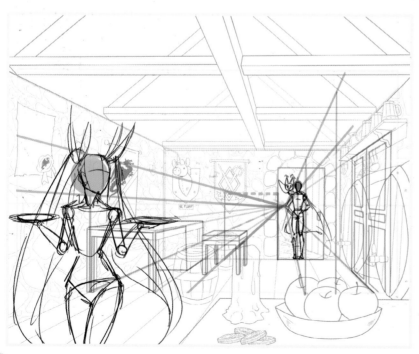

10 Placing door-sized markers in the room can help you compare the size of people in the room with potential furniture. Here door-sized markers were used to place wine barrel taps inside the walls and decorate them in the style of a medieval tavern. The small cube contains enough space to hold a barrel that characters can sit on.

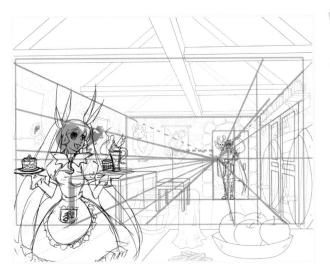

11 Decorating the room is completely up to your personal taste. Just remember to form all the details from the disappearing point. If you have your characters placed correctly, it should be easy to use the previous lessons to form their bodies and dress them.

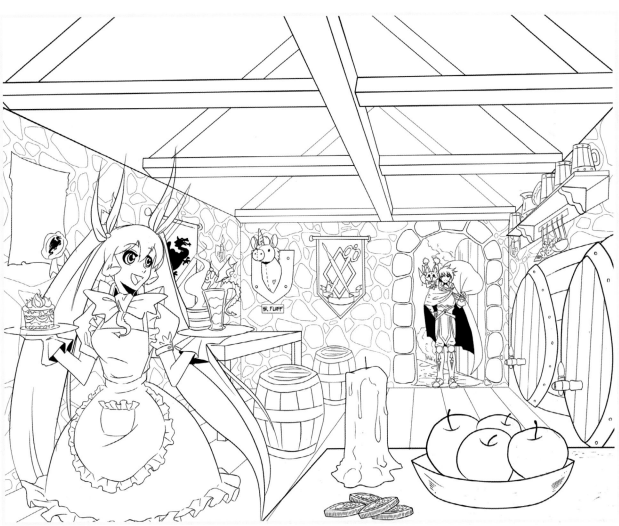

12 The texture of the wall should be done in the thinnest lines possible, so it does not overpower the characters. That is why Maya and everything up close is inked with the thicker lines.

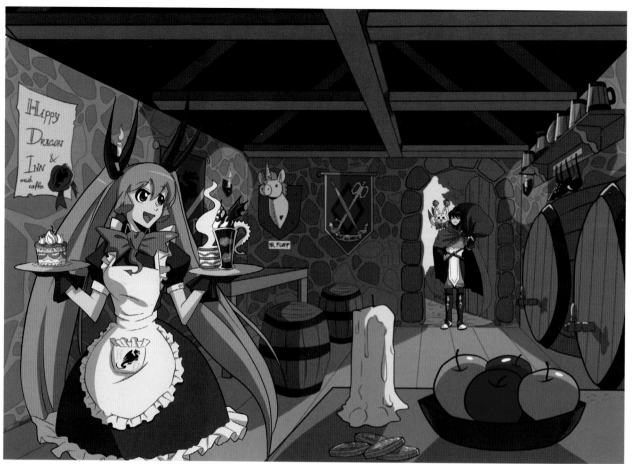

The finished illustration

REFERENCE PHOTOS FOR BUILDINGS AND ROOMS, FURNITURE AND ALL THE SPECIFIC DETAILS ARE AN IMPORTANT TOOL FOR EVERY ILLUSTRATOR IN THE MANGA INDUSTRY.

THE REFERENCE SHOULD ONLY BE A BASE FOR YOUR WORK TO EDIT AND REDESIGN AS YOU NEED.

Additional details: Take notice of the main light source. It can change the way your characters are colored (yellow light). Here you can see the easiest way of showing yellow light: by adding yellow highlights on the side of the objects in the room.

If the general colors in the background are dimmed down, the characters in the front of the artwork will pop better. If the background is too bright and colorful, it can make it hard to see the characters.

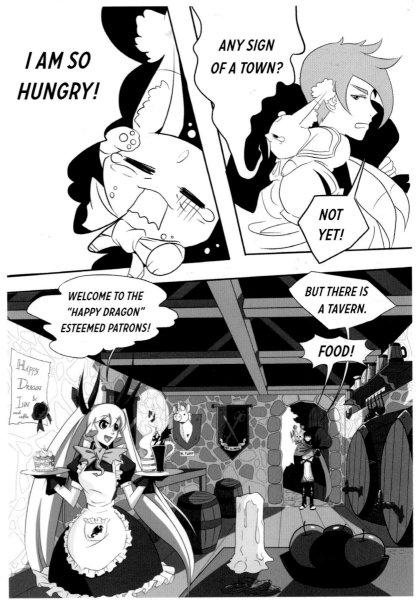

Now let us place this scene in a manga panel. Keep in mind to draw the closer objects with thickest lines, and the background elements, like the wall pattern, with the thinnest possible lines. When drawing manga panel lines for the borders and speech bubbles are drawn in a specific way: The borders are drawn with the thickest lines (applicable mainly in shonen manga) The lines for speech bubbles are thinner than the border lines. The lines within the panels should be thinner than border or bubble lines.

ANATOMY & FACIAL EXPRESSIONS

People instinctively look for faces when viewing any sort of artwork. This is why capturing facial expressions is so important in manga—it is the character's face that draws in and holds the eye of the viewer.

While facial expressions are key to any manga illustration, it is just as important that you are able to depict body anatomy and counter poses accurately. By this point, you should be starting to include counter poses in all of your character poses.

Proper anatomy is key to depicting counter poses accurately. Make sure you count heads every time to avoid mistakes.

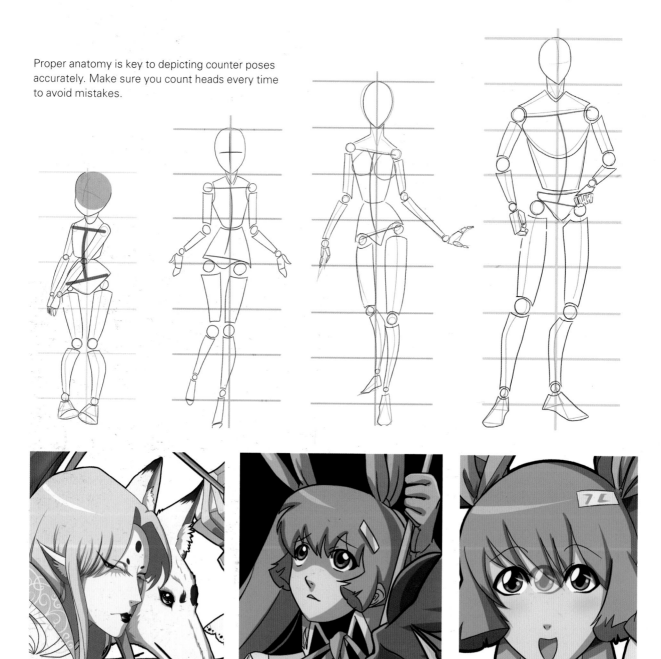

Facial expressions make the viewer want to find out more about what is going on in the picture.

Remember, it is important to keep a distance of one eye-width between the eyes.

COLOR HARMONY

Combining colors in a finished illustration can be done by following a predetermined set of rules. These are just some of the many possible color combinations.

Note that the majority of colors on the wheel are not in their raw form but dimmed down. Also, there is not equal color coverage across all surfaces in the artwork.

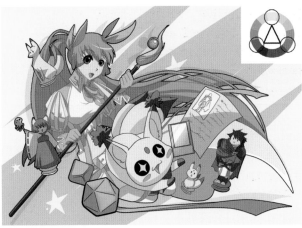

Triadic colors stand equal distance from each other on the wheel. Orange shades are visible on the characters, while the blue and yellow form the background. This combination is best for happy, cartoon-like art.

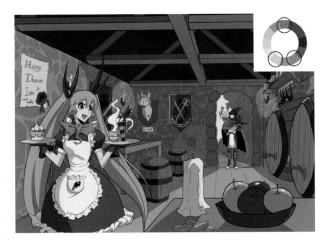

Split-complementary colors are a variation of complementary colors. In addition to the base color, the two colors adjacent to its complement are used. Here the split complementary colors are the red shades in the wood surfaces and the green/blue combo, seen in the main focus point, the door.

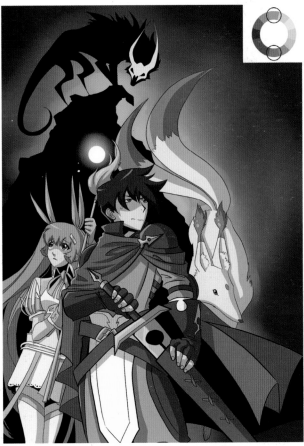

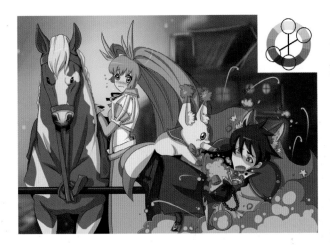

Tetratic colors, also known as double complementary colors, use two sets of complementary colors. The purple smoke in the foreground complements the yellow windows in the background. The orange shades in the characters are complemented by the blue shades of the tavern and the sky in the background.

Complementary colors stand on opposite sides of the color wheel. You can see a lot of red colors in foreground, and the opposite—green—in the background.

COMPOSITION

Composition, the way things are positioned in a drawing, can make an artwork exciting, intimidating or dull. It all depends on how you place the various elements. Just placing characters next to each other is not enough for the art to look like a finished illustration, unless it is a concept art sheet meant more for technical use.

Here are some tips and tricks for enhancing your compositions and, in turn, your manga fantasy art.

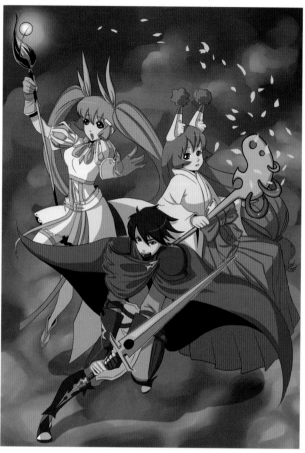

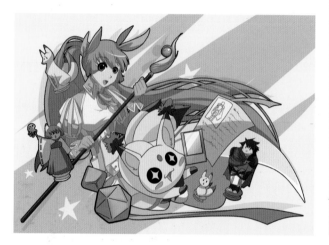

The easiest trick for a successful illustration is to overlap a lot of objects on top of each other.

By adding a bird's-eye view, the entire artwork looks more dynamic and alive.

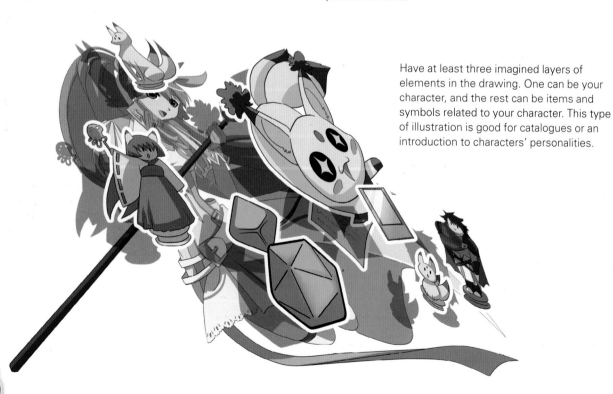

Have at least three imagined layers of elements in the drawing. One can be your character, and the rest can be items and symbols related to your character. This type of illustration is good for catalogues or an introduction to characters' personalities.

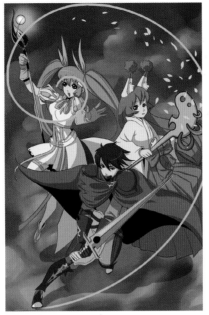

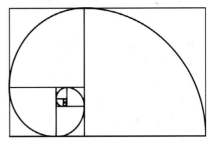

The Golden Ratio is a design principle based on a mathematical equation. It has resulted in some of the most beautiful compositions known in art history. From this equation we got the Fibonacci Spiral, which is used by artists to lead the viewer's eye in a loop, making the artwork look like it is moving.

Here the spiral leads the eye from the bottom of the drawing up over the characters, circling the mysterious beast, and ending right at the magic light—the main focal point.

Here the outline of the petal magic matches the Fibonacci Spiral. It starts from the bottom and ends at Maya's face as the main focal point. This is done deliberately while working the first sketch, or thumbnailing. By planning ahead even before you start the drawing, you are already deciding where the characters will be and what piece of their story will be the main focal point.

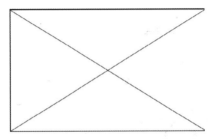

An intersecting-lines composition is easy, yet effective. It is very popular in fantasy because it works well for powerful symmetrical scenes and interiors.

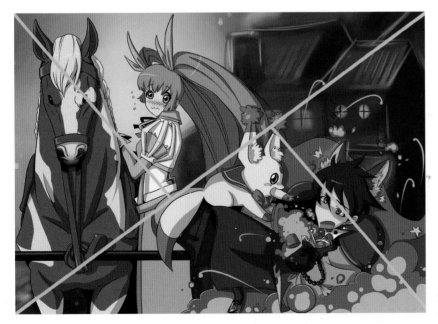

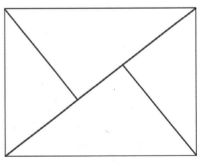

The Golden Triangle is a composition based on a diagonal line going through the art, then connecting to rest of the paper edge with 90-degree-angled lines.

The main diagonal line is very good for drawing action scenes.

THE RULE OF THIRDS

The Rule of Thirds is one of the most commonly used techniques for adding interest and excitement to a composition. The following examples will demonstrate the way this rule works and show you how to use it to enhance your manga fantasy illustrations.

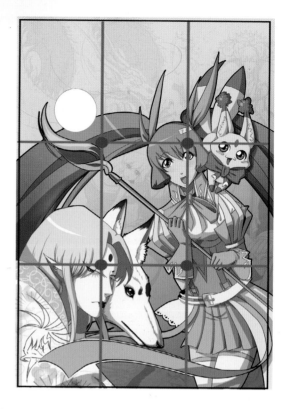

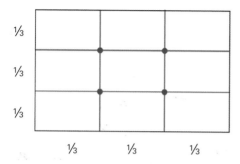

When we divide the paper into nine equal parts, the points where the lines intersect represent the points where the most important elements in the drawing should be placed. The most dominant point is the upper right point.

Maya's and Mimi's heads were placed near the most dominant spot for the best effect. This spot is important because our brains take in information the same way we read—from left to right. So our eyes instinctively go to that upper right area where the text would end if we were reading.

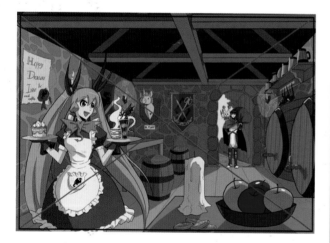

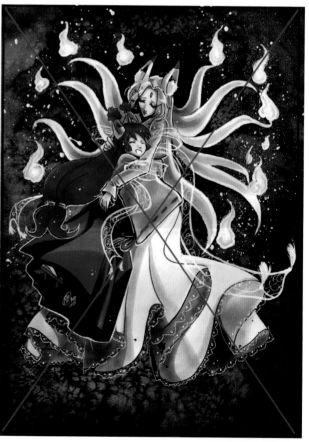

We can see the intersecting lines in the flowing hair and dresses of the characters on the left, as well as where the walls meet the roof on the right side of the illustration. Note that the composition lines should be used for guidance only; they don't need to match 100% with what you are drawing.

DEPTH

To create an illusion of depth, the same rule applies as in the overlapping composition. You need at least three layers in a drawing: a middle layer with your main character, a layer in front of it showing something closer to the viewer, and the background behind both of these layers.

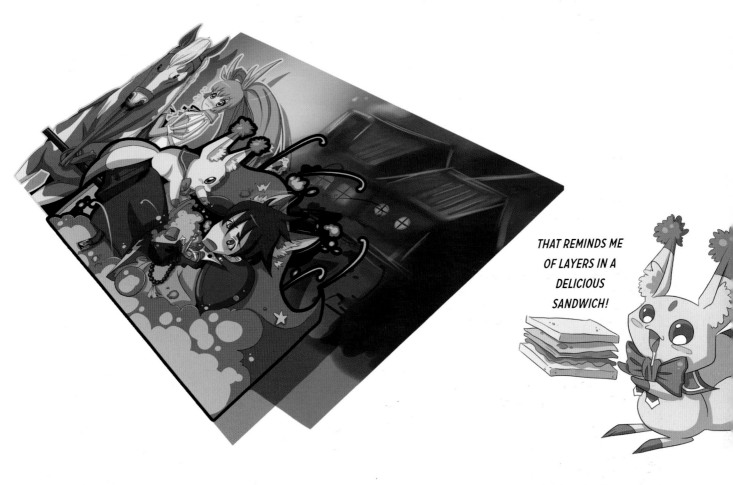

THAT REMINDS ME OF LAYERS IN A DELICIOUS SANDWICH!

Now you are ready to tackle your own masterpieces. Before you do, here is a small checklist of all the things you should not forget to add to it:

- Draw emotions; the more the merrier.
- Use counter poses.
- Research textures and apply them.
- Add a ton of details.

Create a Fantasy Manga Illustration

Follow the steps to create a fantasy manga illustration.

MATERIALS

coloring tools of your choice

eraser

paper

pencil

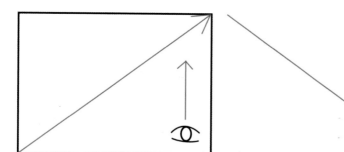

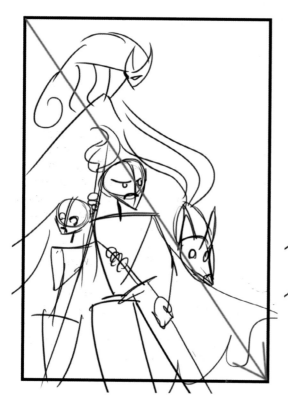

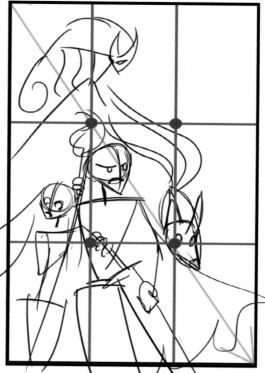

1 Combine different poses and compositions using only stick figures. You are aiming for dynamic, so use a descending line to determine the feel of the scene.

Both of the red lines show a dynamic line, but, since the brain is accostumed to viewing things from left to right, it will read the first line as ascending and the second line as descending. That is why the second line is hidden in many sad, scary or intense drawings.

Make sure that your intense, scary scene follows the descending line, but also remember the Rule of Thirds. You'll need to deliberately plan that the four main marks will contain Maya's glowing magic, Mimi's tail, Marco's hand sheathing the sword, and Mimi's face.

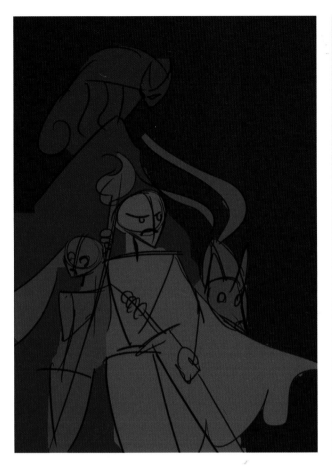

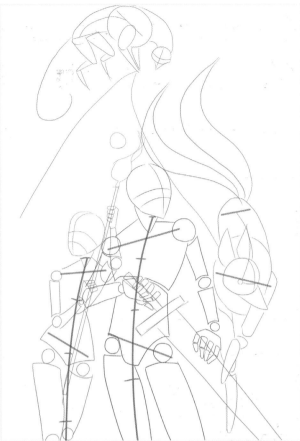

2 Think ahead and plan for the number of layers of depth you want in your drawing while you are making the thumbnail. Here, Marco the Protector will be in front of Maya and Mimi, who are in the second layer of depth. Behind them will be a mound with a mystery monster on it. Behind the mound there will be an eerie background. Although it can be tempting to dive right in, remember that planning out a piece ahead of time will save you a lot of trouble and indecision later on.

3 Correct the bodies, the counter pose and the worm's-eye view. You can see each of the lower heads getting slightly bigger. This influences the need to make the characters' hips a bit bigger and their thighs a little thicker. It is a subtle change, but enough to give the illusion of a worm's-eye view.

The counter pose is visible with both humans and animals. Even though the character in the foreground will cover the background characters later on, all of the character bodies should be planned and completely drawn out.

Make sure all of the poses are accurate if your characters are using weapons.

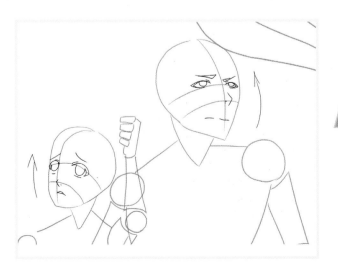

4 Part of creating the worm's-eye view involves raising all parts of the face so that it appears as if the characters are looking up. Here you see Maya's scared expression and Marco's cautious, nervous expression. This will influence the atmosphere of the work significantly.

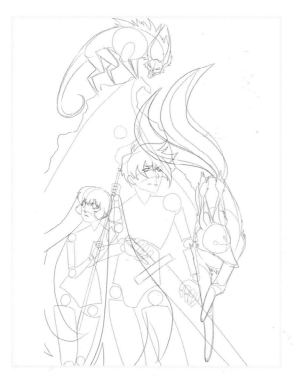

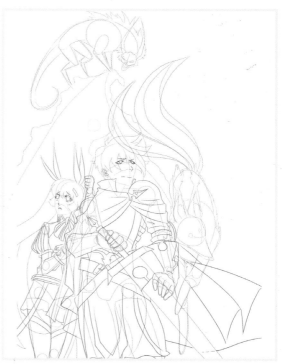

5 Now it's time to "dress up" the characters by adding clothes, hair, fur and other details to the beast characters. Fur and hair both add a lot of volume to the body, so never be afraid to show that. The volume rule especially applies to clothing. This is the first point where you will be overlapping elements of the drawing, because this is where you plan the final line art.

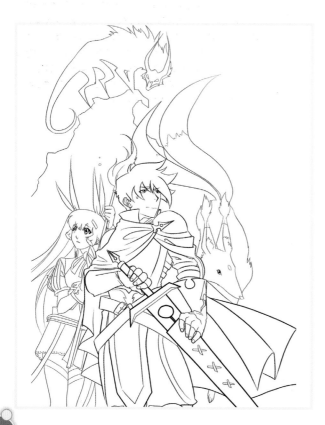

6 Final line art in manga needs to be smooth. Unless it's an artistic approach, outlines make the most of manga and anime aesthetics. Here, Marco and the sword are outlined thickest. Maya and Mimi are outlined with medium lines, and the background is outlined with the thinnest line.

The same applies to the amount of details: place the most details on the characters that are closest to the viewer. The farther away something is, the less detail it should have.

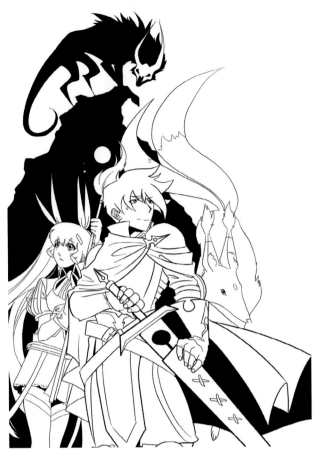

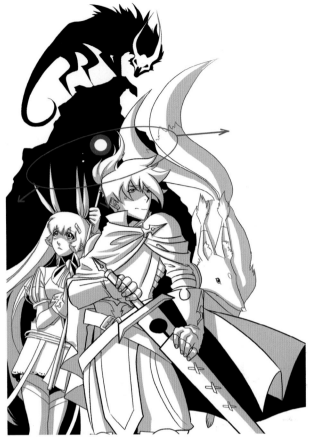

7 Since this is an intense, dark and heavy scene, more black surfaces help with the overall atmosphere. It is completely up to your taste how much contrast you want in your art, and you may choose not to even use black areas. If you do, however, remember that around 30% of your work covered in black makes for an effective contrast. This is used in both manga and illustrations, and helps you see the secret behind manga-style shading. Covering entire surfaces—not just shaded edges—is the secret. It is easy, quick and very effective.

8 Illustrations and fashion photography tend to have dual light sources in opposite colors to add to the dramatic effect. Here you will mainly focus on one light source: the magic staff glow. The sunglass type of face shading is very dramatic and can be used as a pattern for a floor light source, a horror effect or, as in this image, a suspense scene.

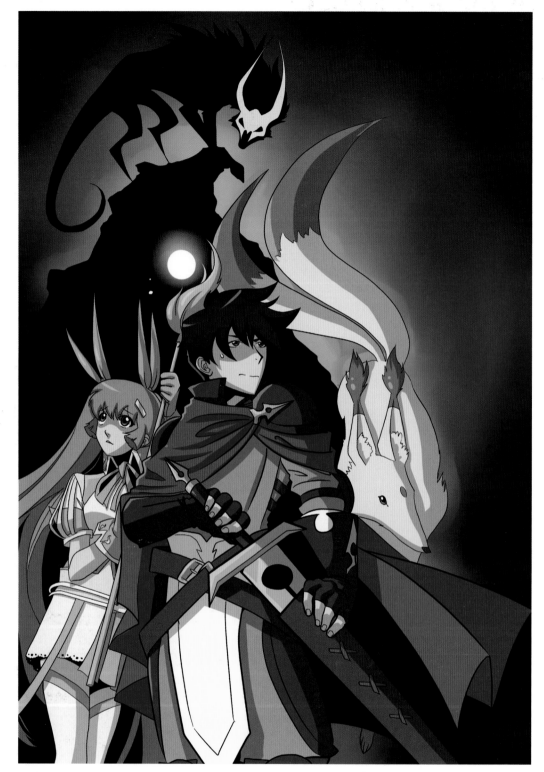

If the right column of colors were used in this scene, it would be too difficult to view.

9 Muting colors is imperative for effective artwork. In this entire piece, there is only one color that is close to its pure and bright form, and that is the background. Purposefully place bright colors on details you want to emphasize. Take a look at the final color palette compared to the bright version of the colors.

LET'S PLAY A GAME!

Just as in my first book, *Manga Crash Course*, we are going to have some fun turning the process of designing manga fantasy characters into a game. And remember, just because a process is fun, that doesn't mean it's not professional. This is the same method many professional manga artists use to create their characters.

Imagine six heroes who will be part of a role-playing game. They can be different genders, different races, and have different abilities and ultimately work as a team, just like you might see in a video game.

To implement all the lessons from this book, we will be creating characters based upon different aspects of the lessons:

- Our heroes will have various heights.
- Half of the heroes will be male and half female.
- We will design characters based upon these creatures: mermaid, vampire, werewolf, unicorn, sphinx and dragon.
- The characters will follow a silhouette of power or the silhouette of an adventurer.
- We will use different clothing and fashion influences on each character.
- Each character will have a unique class within the team.

	GENDER	HEIGHT IN HEADS	SPECIES	SILHOUETTE	CLOTHES/ARMOR	CLASS
1	male	10	mermaid	power	armor	cleric
2	female	7	vampire	power	Renaissance	tank
3	male	7	werewolf	adventurer	18th century	sorcerer
4	female	5	unicorn	adventurer	Victorian	assassin
5	female	6	sphinx	adventurer	high school	summoner
6	male	8	dragon	power	samurai	gladiator

By assigning each of the six characters to a specific class, it will be easier to imagine them working together, like in a video game. Tank defends the team, while Cleric heals the wounded. Sorcerer casts spells, while Assassin sneaks around and shoots arrows. Summoner controls a fantastic spirit beast, and Gladiator goes head to head with his enemies.

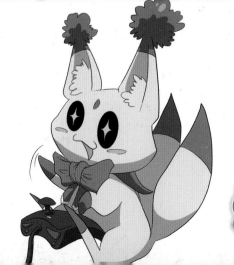

Cleric Merman

"Cleric" is the backbone of the team. He heals, protects and fights as a force to be reckoned with. But what happens when the most important part of the team can't function on land? Does the team use magic, keep him in a bubble, or summon a merman? Imagine all the hilarious scenes and possibilities.

MATERIALS

coloring tools of your choice

eraser

paper

pencil

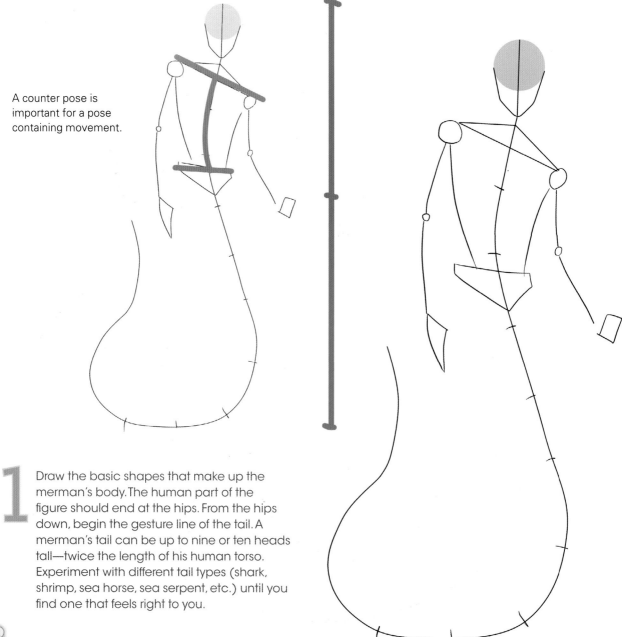

A counter pose is important for a pose containing movement.

1 Draw the basic shapes that make up the merman's body. The human part of the figure should end at the hips. From the hips down, begin the gesture line of the tail. A merman's tail can be up to nine or ten heads tall—twice the length of his human torso. Experiment with different tail types (shark, shrimp, sea horse, sea serpent, etc.) until you find one that feels right to you.

2

Fill in the form of the tail. It should start to curve at the height of the sixth head. Then, draw his weapon, the trident. Next, block in the shape of his hair. Remember, he is under water, so the hair will take on a swirly shape. Begin adding basic shapes for the ears and fins. Choose any style you like for these details, but they should be kept similar. For this particular character, a pointy design was used.

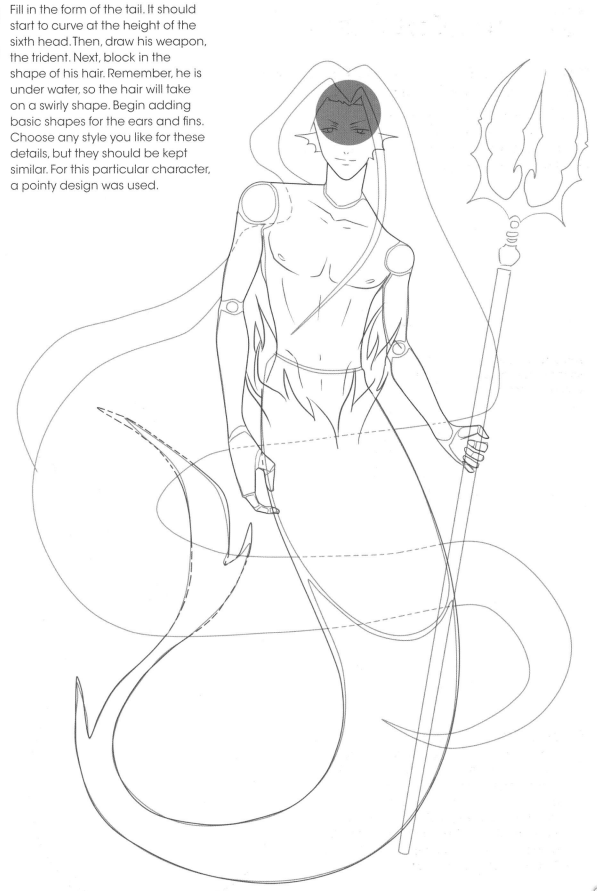

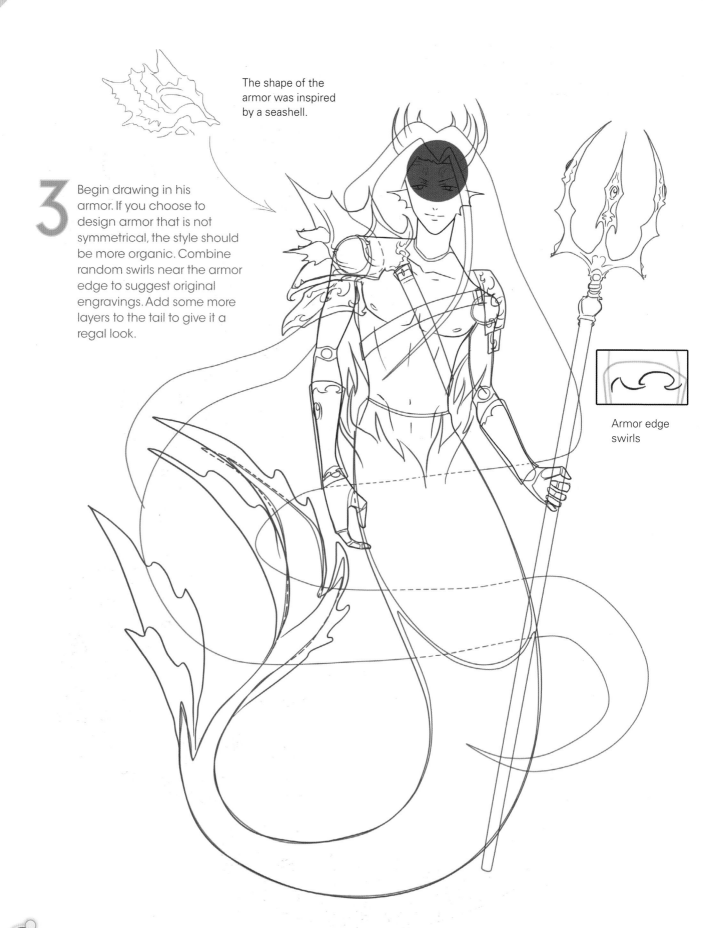

The shape of the armor was inspired by a seashell.

3 Begin drawing in his armor. If you choose to design armor that is not symmetrical, the style should be more organic. Combine random swirls near the armor edge to suggest original engravings. Add some more layers to the tail to give it a regal look.

Armor edge swirls

4 Shade the character. When shading the trident, keep in mind that shadows on metal often do not touch the edges of the object. Most of the lower portion of the hair should be shaded because it falls behind the character. To give the tail a textured look, criss-cross the edges of the tail shadows.

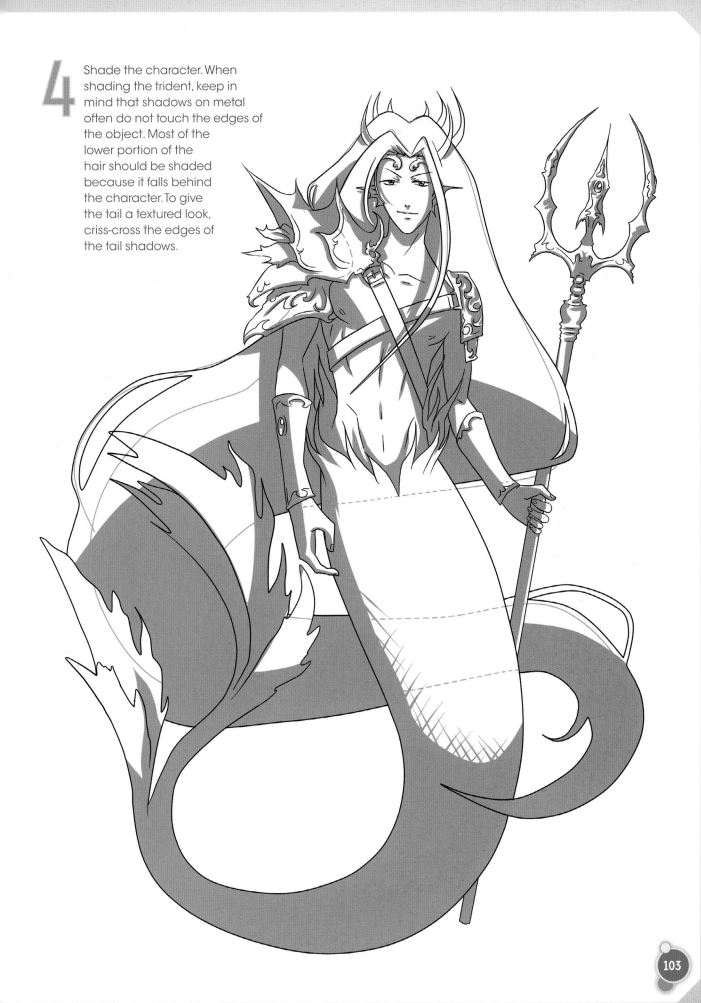

5 Color your character with the coloring supplies of your choosing. Typically, a manga character should have up to five colors, but you can use more or less if you like. A color palette consisting of both warm and cool colors will lend a nice contrast to your character. Add highlights to the hair and the trident. These should fall towards the middle of these colored surfaces. Finish it off by adding some yellow stripes to the tail.

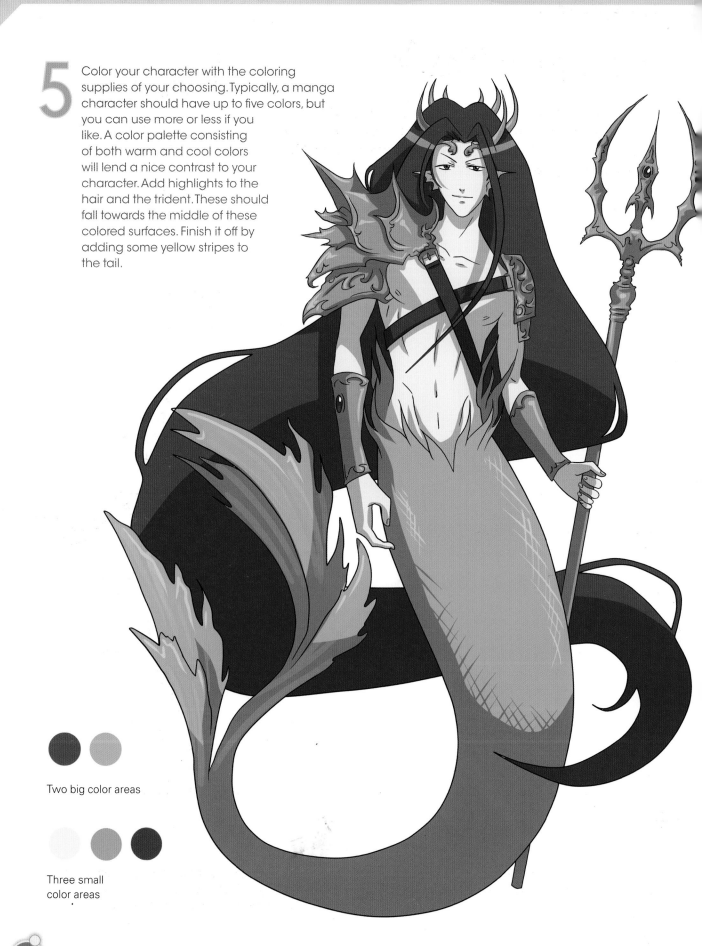

Two big color areas

Three small color areas

Vampire Tank

"Tank" is a nickname for a class of characters in video games that are the type of warriors that can take and deal the most damage. Our Tank will be a female vampire with a specific design revolving around her theme.

 MATERIALS

coloring tools of your choice

eraser

paper

pencil

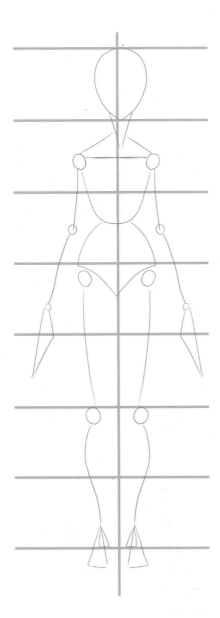

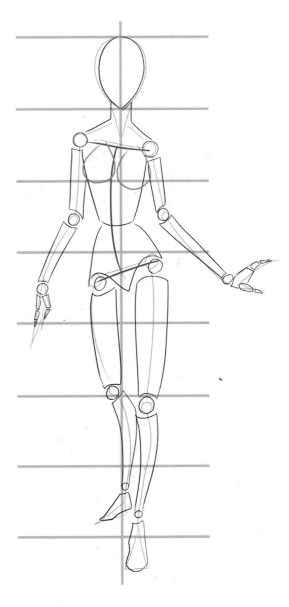

1 Block in the basic body shapes of an adult female. She should be seven heads tall.

2 Adjust the torso shape and position of the arms and legs into a counter pose to make her appear as if she is stepping out.

3 This character will be at the front lines in battle using a combination of her claw weapon and a gun for further targets.

Since vampires have strong symbolism connected to blood, incorporate a syringe design into the character's weapon. Here it is more of a gun with red-colored magic.

Design the shoes after the style of shoes concubines wore to symbolize a seductive character.

For this design, base the general shape after the power silhouette and add details of a Renaissance dress.

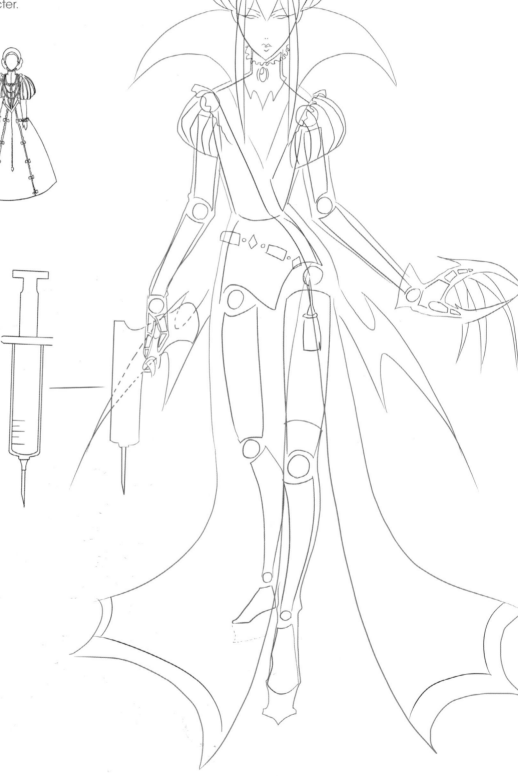

4 In manga, bat wings attached to hips represent more of an aesthetic choice than a practical one.

This red magic has no contours, just five shades of red painted together to form a mystical shape.

The repeating pattern here was inspired by a Renaissance fence design. It could also be a secret shield.

When drawing lipstick, it is good to draw the upper lips as a few shades darker. Leaving out white corners imitates an effect of highlights.

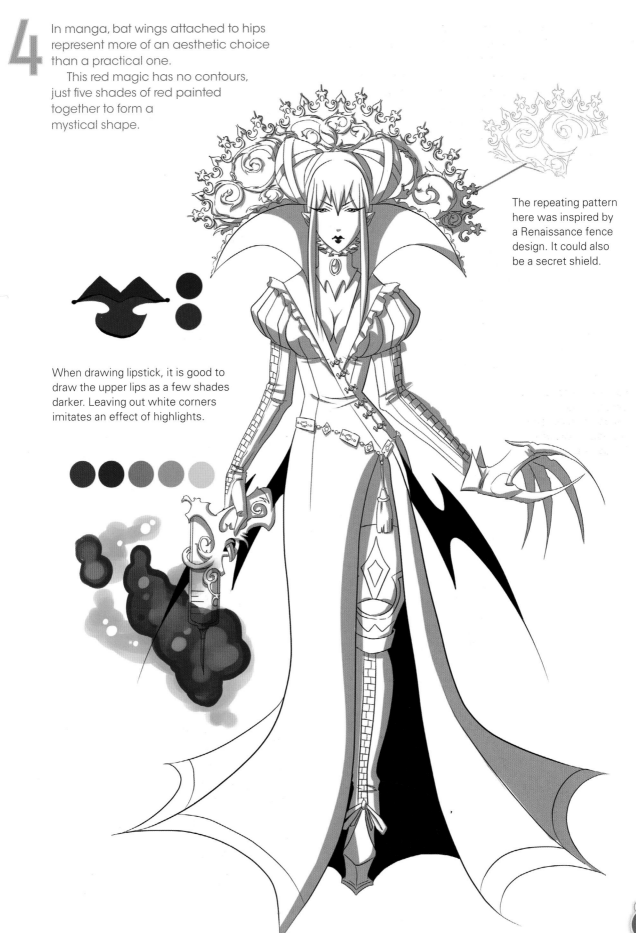

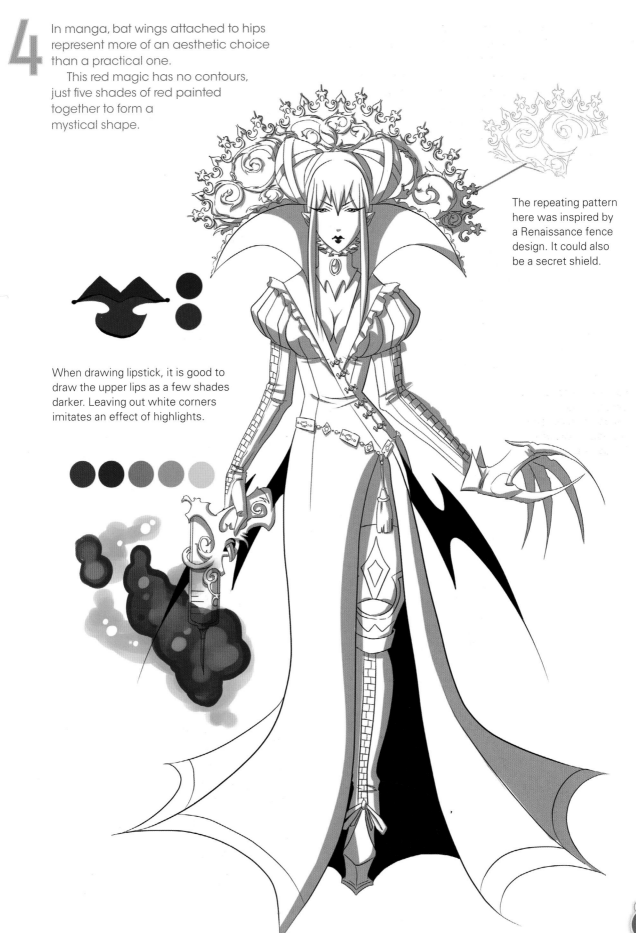

5 When in doubt add patterns! They always make a surface look rich. Add details to the syringe such as dose lines and the main mechanism to lend a realistic feel to the weapon.
Add swirling gold lines around the gun with one shade of color. This will make it appear as if it is pulsating with energy.

A very simple color palette was used.

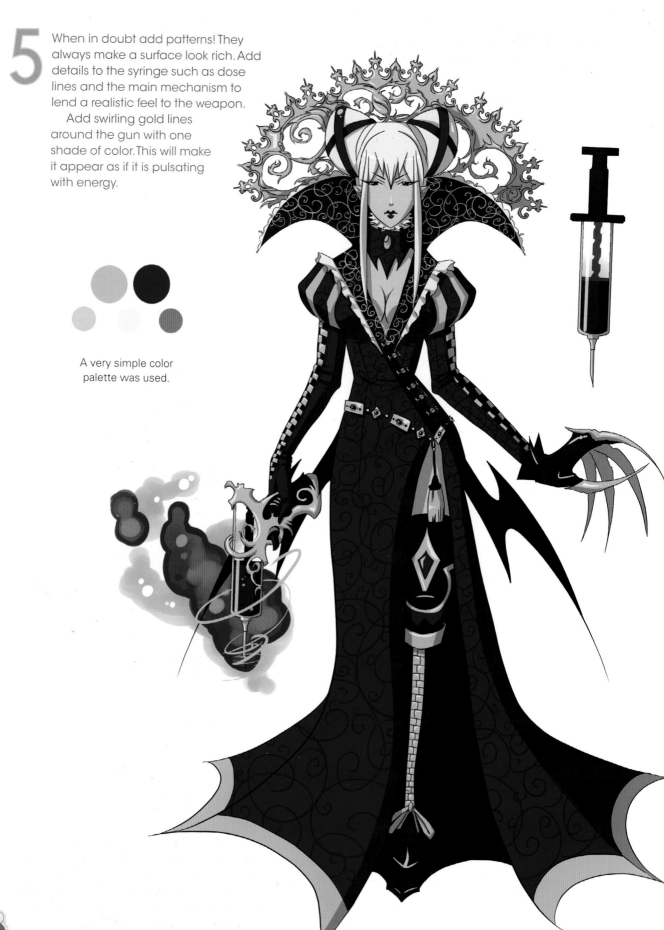

Wolf Sorcerer

Sorcerers cast spells to make illusions, cause damage, or sometimes just to make a flashy show. This character should also possess the visual traits of a werewolf. To strike a balance, we will design this character as something in between human and wolf, but also a peaceful type of creature. This will allow us to get a good balance symbols along with an interesting concept.

MATERIALS

coloring tools of your choice

eraser

paper

pencil

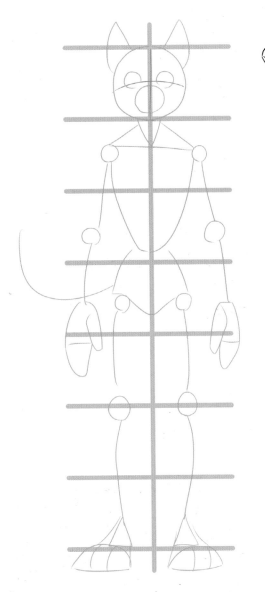

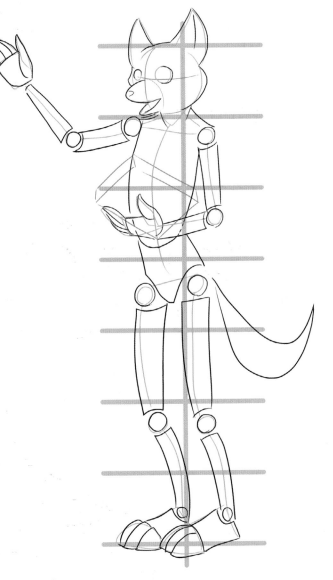

1 Block in the basic body shapes. He should be seven heads tall. The shape of his head is a circle, and the ears should not be included in the head size.

2 Adjust the shape to a counter pose to make it look like he is casting a spell. Make one hand raised to cast and the other in a position to hold a spell book. For this type of character, it is a good idea to add enlarged hands and paws instead of feet.

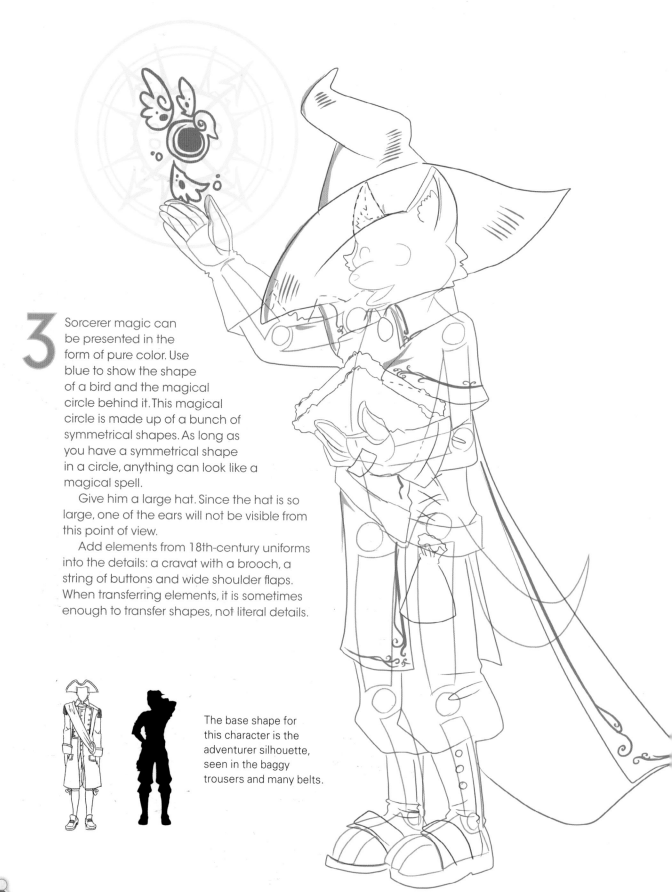

3 Sorcerer magic can be presented in the form of pure color. Use blue to show the shape of a bird and the magical circle behind it. This magical circle is made up of a bunch of symmetrical shapes. As long as you have a symmetrical shape in a circle, anything can look like a magical spell.

Give him a large hat. Since the hat is so large, one of the ears will not be visible from this point of view.

Add elements from 18th-century uniforms into the details: a cravat with a brooch, a string of buttons and wide shoulder flaps. When transferring elements, it is sometimes enough to transfer shapes, not literal details.

The base shape for this character is the adventurer silhouette, seen in the baggy trousers and many belts.

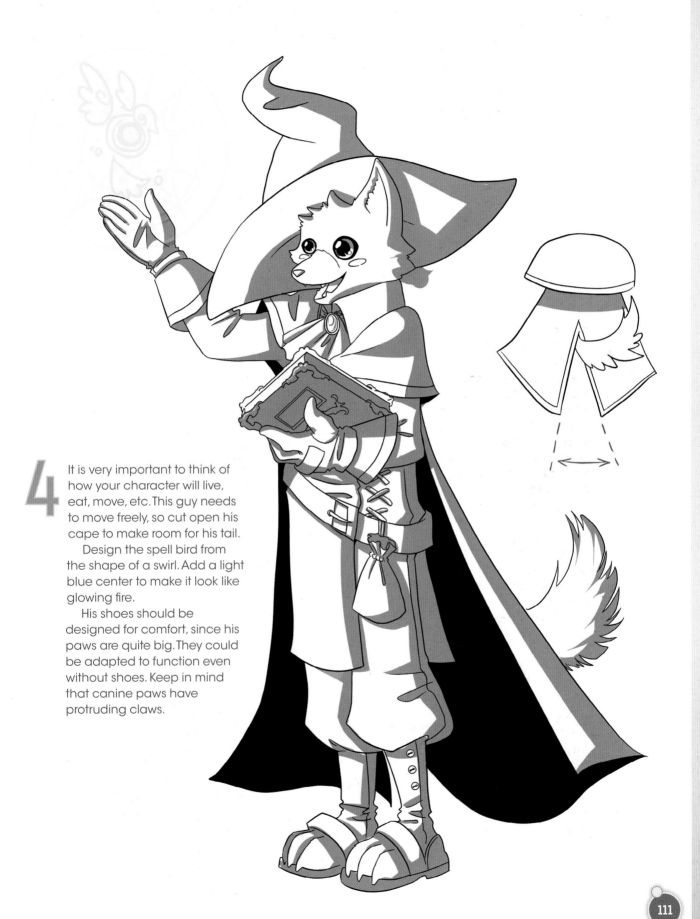

4 It is very important to think of how your character will live, eat, move, etc. This guy needs to move freely, so cut open his cape to make room for his tail.

Design the spell bird from the shape of a swirl. Add a light blue center to make it look like glowing fire.

His shoes should be designed for comfort, since his paws are quite big. They could be adapted to function even without shoes. Keep in mind that canine paws have protruding claws.

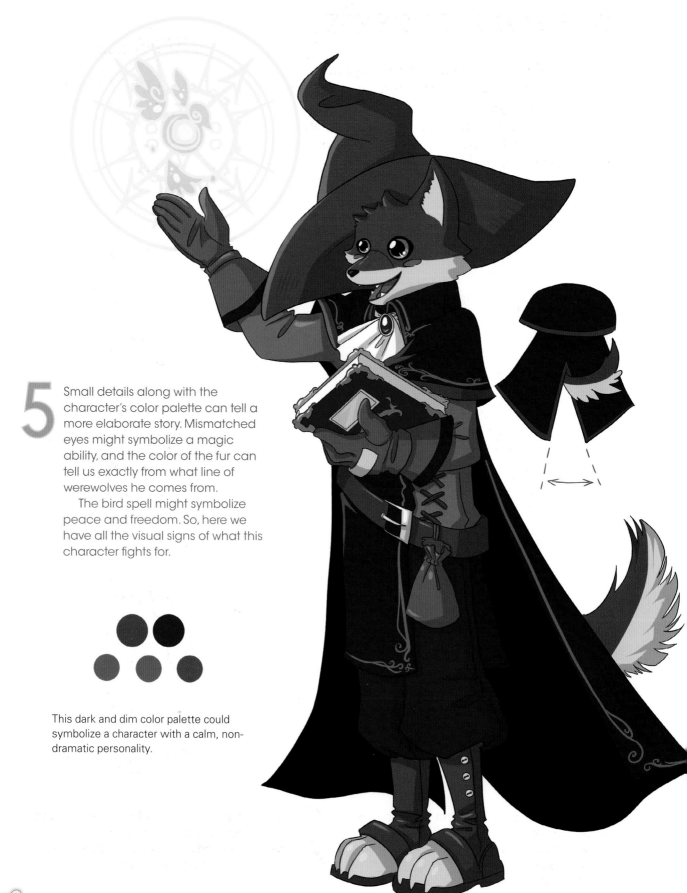

5 Small details along with the character's color palette can tell a more elaborate story. Mismatched eyes might symbolize a magic ability, and the color of the fur can tell us exactly from what line of werewolves he comes from.

The bird spell might symbolize peace and freedom. So, here we have all the visual signs of what this character fights for.

This dark and dim color palette could symbolize a character with a calm, non-dramatic personality.

Unicorn Assassin

It is fun and challenging to combine two opposing meanings into one character. In this case, we will create a character that is a symbol of purity and innocence, but also an assassin. In many anime series, concepts like these are comical in nature, so we will be going for a comical effect in the final design.

 MATERIALS

coloring tools of your choice

eraser

paper

pencil

1 Block in the basic body shapes. This character will be five heads tall, so she will have more of a childish size. Her pose should reflect her shy nature. This can be accomplished by placing her knees and feet close together.

2 This design will be mainly human in form, with a horn added to represent the unicorn. The weapon should be visible as a base to make sense of the character's pose.

3 For a comic element, add small hearts throughout—especially on the weapon—to make her a sort of Cupid character.

Add a mascot to this whimsical character in the form of a unicorn bomb creature. Tiny details like Cupid wings and the kitty paw grappling with the hook peaking from her pouch tell a more complete story about the character. Now you can truly imagine her adventures!

The adventurer silhouette is present from the visible thigh area. It is emphasized by pumpkin pants and a wide lower skirt-like area. Crossed details on shoes are a relatable motif, and the Victorian dress influence is visible in the details: frills, bows, bonnet-like hood, collar and even the curled hair.

4 More additional details can enrich the character and deepen the story, or give insight into how the character functions.

By adding magic smoke with little skulls and hearts, you can make the arrow look poisonous or enchanted. Additional engravings or markings can also help tell the story, or they can just be there for extra decoration.

The shading here looks simple, but it is actually a combination of line thicknesses, the black area in the back of the skirt, and main shadows marked in gray.

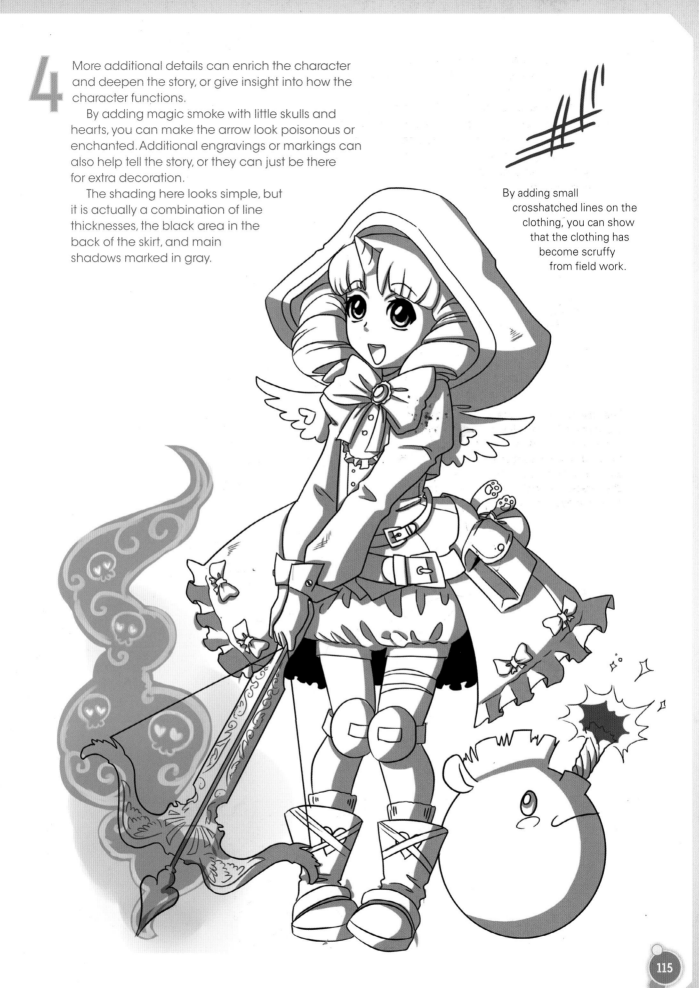

By adding small crosshatched lines on the clothing, you can show that the clothing has become scruffy from field work.

5 Adding swirls inside the smoke will give a less realistic and more cartoony feel to the drawing, which serves this character well.

The lit fuse of the bomb creature serves the purpose of frightening enemies. When drawing flames, remember to always place the brightest color in the center of the flame no matter what color the flame is.

Use a candy-colored palette so the character looks as happy and joyous as possible.

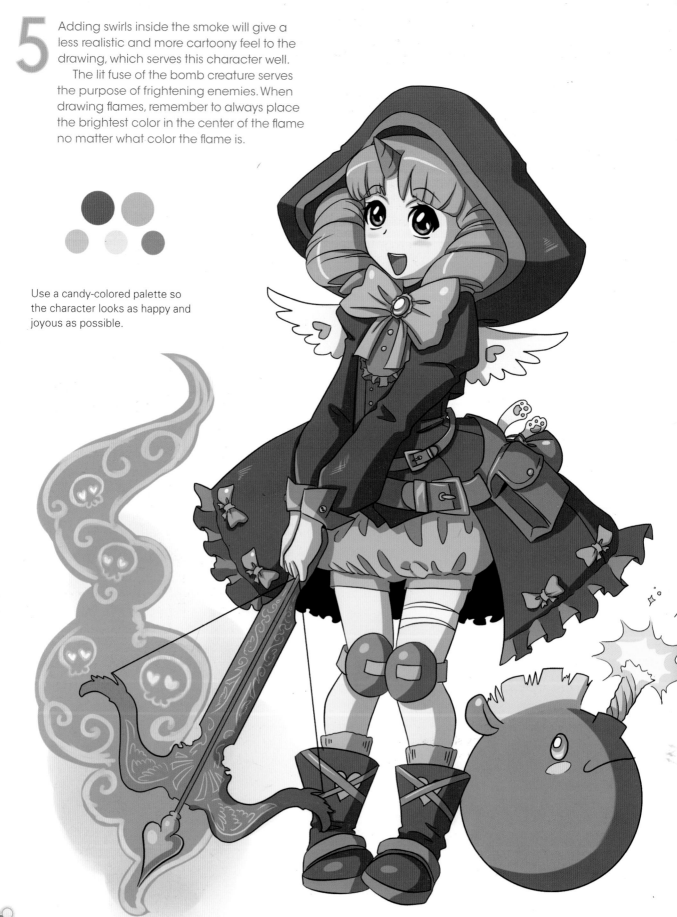

Sphinx Summoner

Summoners are the part of the team that can create and control spirit creatures from thin air. These formidable warriors don't need to be big in size, as long as their spirit protector is strong enough. Summoners are masters at magic, so this character pose will be a floating one, symbolizing that she can master so much magic that she can make herself levitate. Since her main theme is an Egyptian Sphinx, give her mane-like hair, lion ears and a tail as an added base to her female body.

MATERIALS

coloring tools of your choice

eraser

paper

pencil

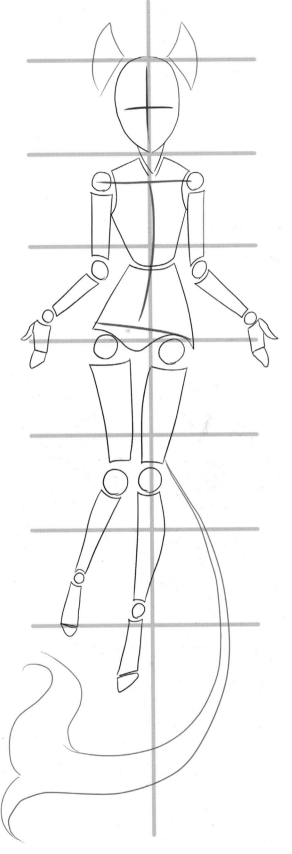

1 Block in the basic body shapes. In floating poses, the body tends to bend in a counter pose, even if only slightly. This makes the character look like she is floating through the air. Emphasize her proud demeanor by giving her straight shoulders and a high and proud chin so that she looks worthy of her mythical heritage.

2 Slowly merge the dress shape into a pleated high-school-skirt shape to combine ancient drapery with a modern look.

The front of her thigh should be marked by a serpent. This is one of the most powerful symbols of ancient Egypt; she is literally wearing the meaning of life and death itself.

Add a rich collar to represent her royal status, which can tell us more about the character.

The adventurer silhouette is only slightly hinted at here in the form of a wide skirt. The other elements belong more to the school uniform. Manga aesthetics prefers the high-school-girl look above all else, and so we have a potentially popular concept here—a Sphinx school girl.

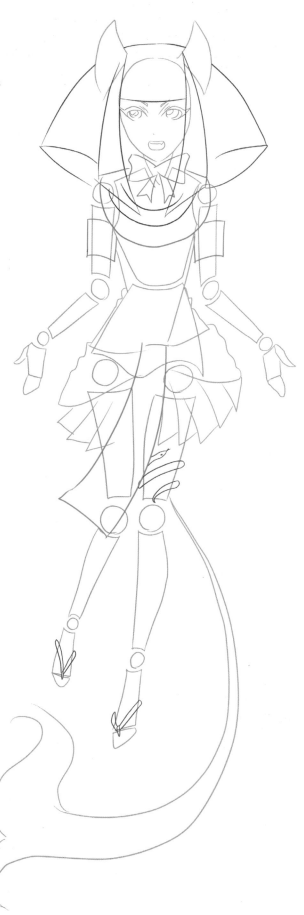

3 Add a scarab (beetle) to the bow on her collar as another powerful symbol in Egyptian mythology—that of reincarnation and eternal life.

Include a hieroglyphic-style list of creature silhouettes on her loincloth. This tells us that she can probably summon any of these to serve a different purpose, based on their different appearances. Then use one of the silhouettes in the background to represent a summoned spirit. Since this spirit is pure magic, it should not contain any outlines.

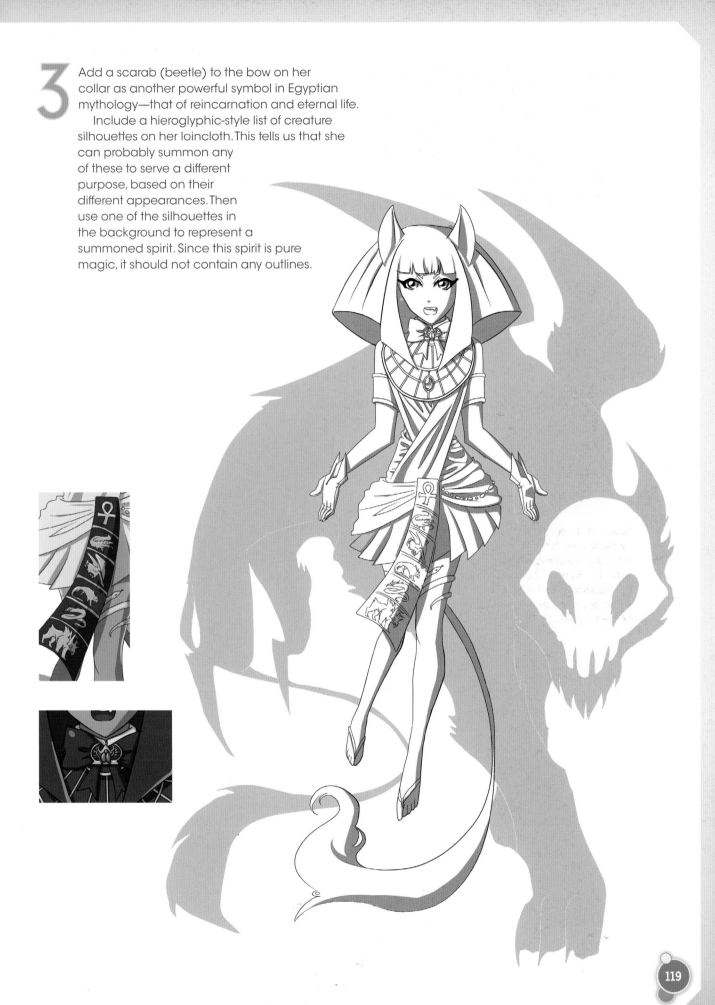

4 The summoning magic can be represented differently from other types of magic. Adding a glow to her eyes and bone tattoos to her legs will represent the symbolic process of calling creatures from the spirit world.

Use a color palette featuring gold and blue to represent life, rebirth and eternity.

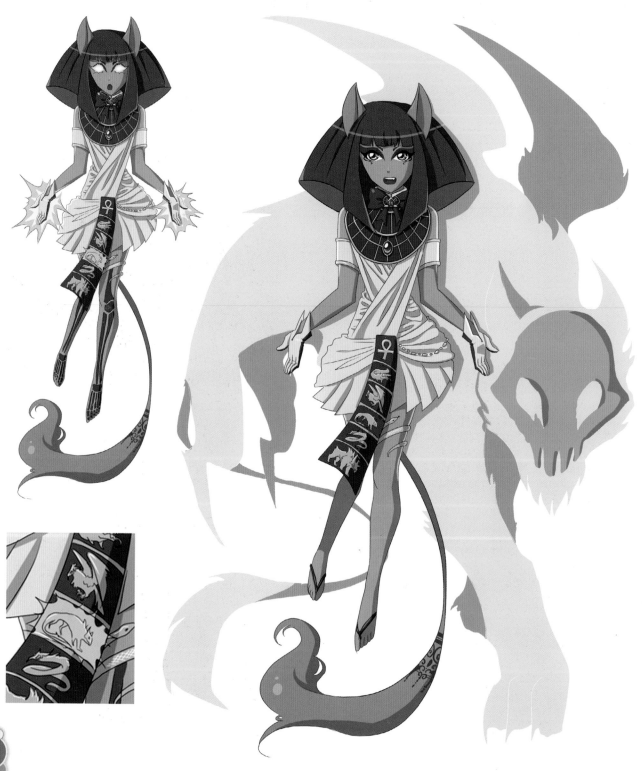

Dragon Samurai

This character has the position of the gladiator/warrior in the team. He deals a lot of damage swiftly, but doesn't have as much defense strength as the Tank does. This character is tall and wields a massive blade. His main theme is an Asian dragon, symbolizing ultimate wisdom, which can help to develop this character as a highly calm and calculated personality, yet fearsome opponent.

 MATERIALS

coloring tools of your choice

eraser

paper

pencil

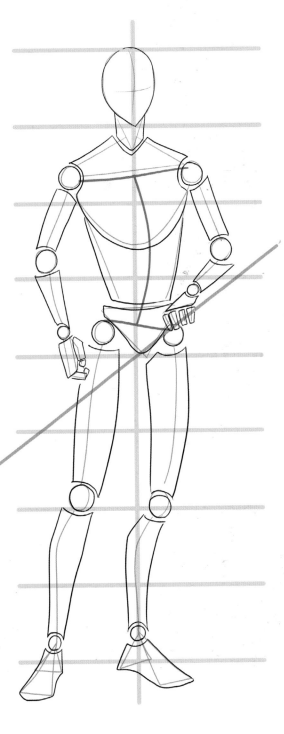

1 Block in the basic body shapes. This character will be eight heads tall. In manga and anime, it is common for characters to wield ridiculously big swords. In Japan, there are such swords, but they are mostly used as ceremonial and decorative weapons. The pose here should represent a character holding up his sword in an alert stance.

2 Introduce some playful asymmetry by adding tall pauldrons. They should be the same height, but different shapes. Instead of drawing a cape, have the character's hair flow out behind him in a shape of a dragon's tail and whiskers. Dragon scales should also be made a part of the overall look, but they can be represented by the chest piece.

The power silhouette is clearly visible in the character's horned helmet, which is a common element in the samurai armor. The horn shape was made after the dragon horns.

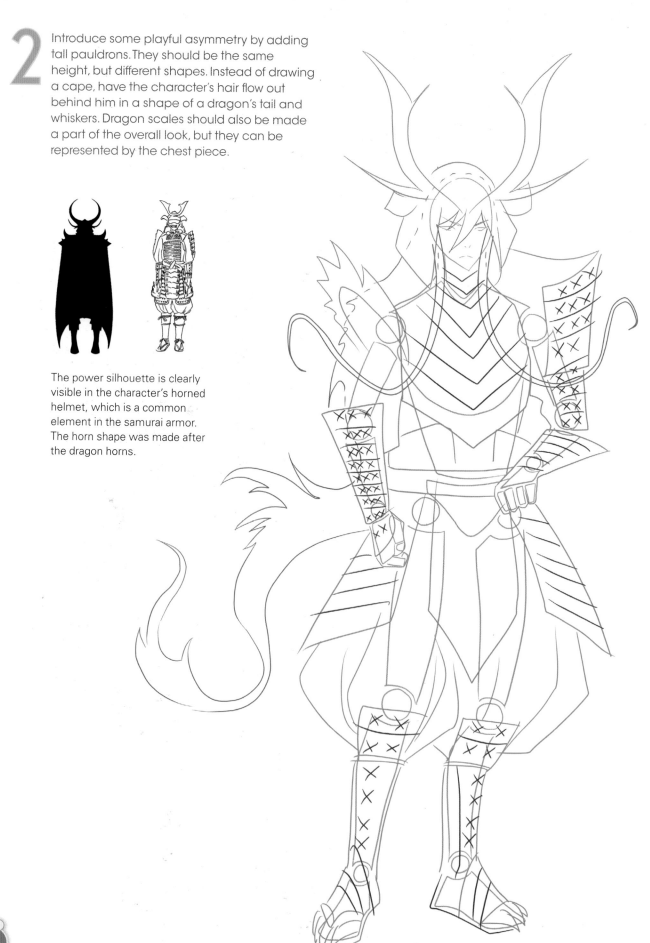

3 Even the sword should have the details and colors of a dragon. Add scales, claws and metallic fur shapes to it, as well as some bandages at the transition from hilt to blade. This will symbolize an experienced warrior.

Make the blade as tall as the samurai himself. This tells us that his specific magic is not visible, but lies within his abnormal natural strength and speed.

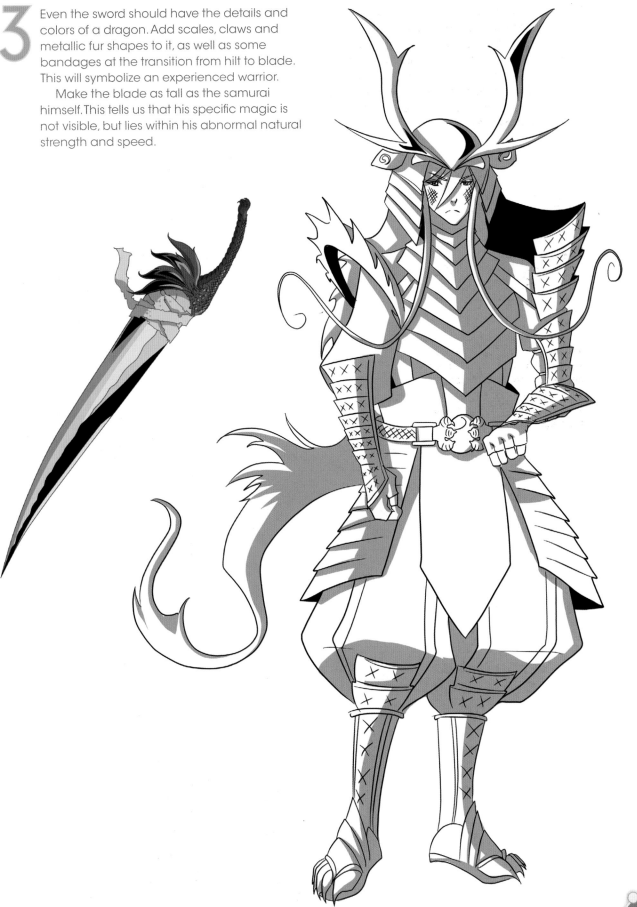

4 Use an overall color palette that is complementary but timid, holding colors that are on the opposite side of the spectrum from one another.

Add a small piece of symbolism to his belt by including an amber stone to represent his stability and wisdom.

Translate the dragon theme onto the armor and weapon, and give the shoe design the illusion of dragon feet.

The main colors of this palette should be complementary and symbolize an internal struggle within this character.

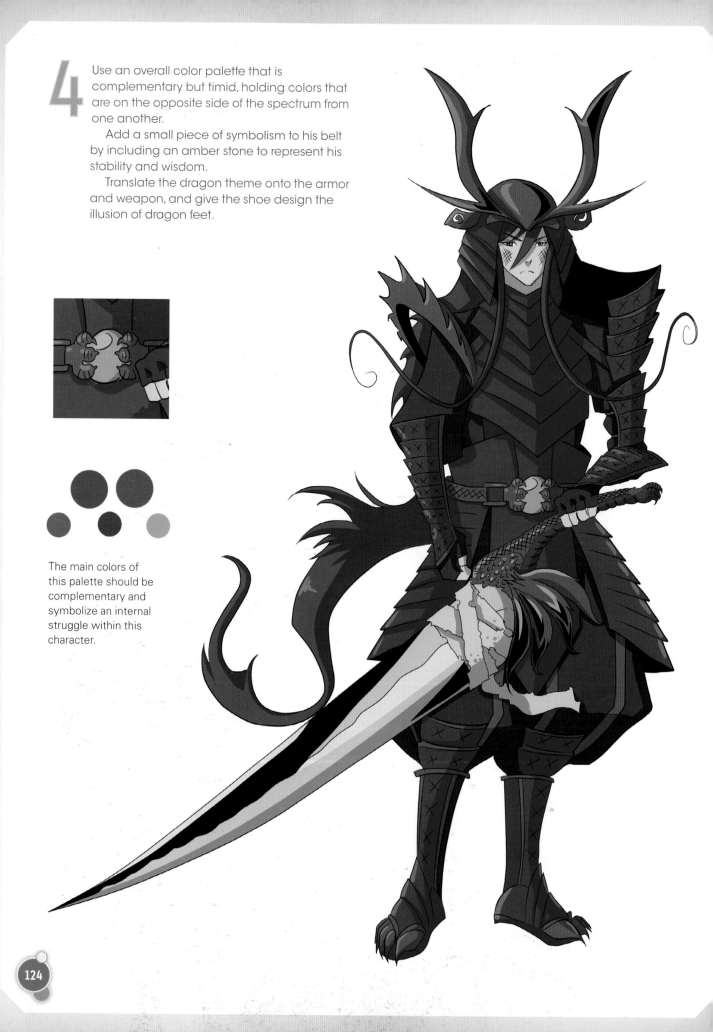

CONCLUSION

"Mistiqarts" was a name I chose for my craft as a symbol of my wish to one day create fantastical imagined worlds, creatures and stories. Fantasy has always influenced my art and work. I wanted to share with you all of the knowledge I have collected through the years. I want this book to be a useful ally to you, as well as your guide into the realms of imagination, making your artistic journey as pleasurable as possible. Anyone can create their own worlds and, through drawing, share them with the world. That is exactly why I consider art a true form of real magic.

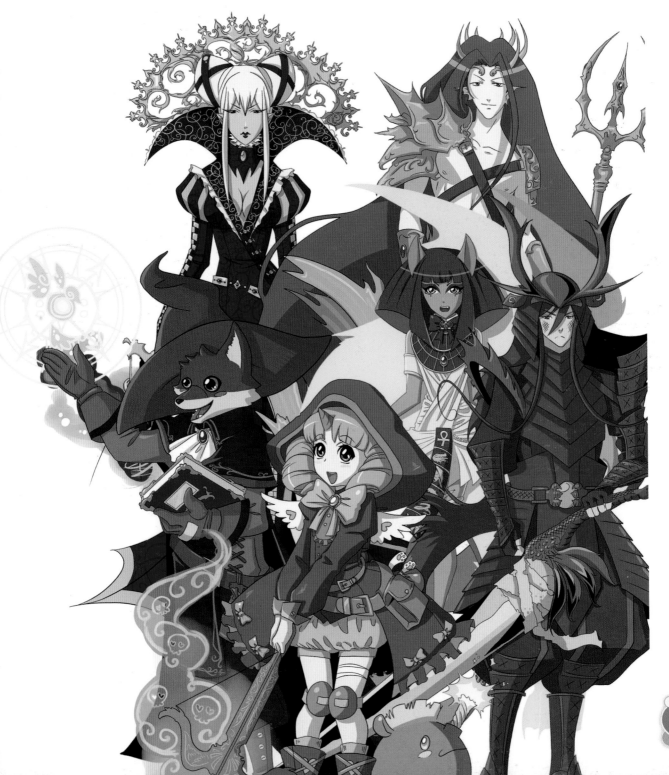

INDEX

a content + ecommerce company

Other fine IMPACT Books are available from your favorite bookstore, art supply store or online supplier. Visit our website at fwmedia.com.

21 20 19 18 17 5 4 3 2 1

DISTRIBUTED IN CANADA BY FRASER DIRECT
100 Armstrong Avenue
Georgetown, ON, Canada L7G 5S4
Tel: (905) 877-4411

DISTRIBUTED IN THE U.K. AND EUROPE
BY F&W MEDIA INTERNATIONAL LTD
Brunel House, Pynes Hill Court, Pynes Hill, Rydon Lane,
Exeter, EX2 5AZ, United Kingdom
Tel: (+44) 1392 79680
Email: enquiries@fwmedia.com

ISBN 13: 978-1-4403-5004-7

Edited by Christina Richards
Designed by Jamie DeAnne
Production coordinated by Jennifer Bass

About the Author

Mina Petrović, better known as "Mistiqarts" is a manga illustrator and teacher from Belgrade, Serbia. In 2009, she graduated with a degree in fashion design and won first place in a manga competition organized by the Embassy of Japan in Serbia. Since then, she has created one of the top manga workshops outside Japan as a part of the "Sakurabana" fan society. Mina also works as a convention organizer and a lecturer on Japanese pop culture in asociation with the Japanese embassy in Serbia. She is the author of *Manga Crash Course,* and is a well known Youtuber, bringing her manga lessons to aspiring artists on her channel: youtube.com/mistiqarts.

Acknowledgments

An enormous thank you to my darling assistants and students, without whom this book wouldn't be as colorful as it is. Marina, Jovana, Sanja and Damien, you guys have grown up to be most beautiful people I have ever seen, and I am so proud and honored to have seen it with my own eyes. Also, my life and work would have never been completed without the support of my parents, friends, family and my extended "Sakurabana" family—I love you more than anything. And last but definitively not least, to all of you reading this book, thank you for believing in me.

Dedication

I dedicate this work to my muses, who helped and sticked by me in the darkest of times: Laura, Brandy and Cynthia, who appreciated me even in times I doubted my own strength and talent. You are the most amazing , powerful gang of gals, and I can only be honored to be your friend.

Metric Conversion Chart

To convert	to	multiply by
Inches	Centimeters	2.54
Centimeters	Inches	0.4
Feet	Centimeters	30.5
Centimeters	Feet	0.03
Yards	Meters	0.9
Meters	Yards	1.1

IDEAS. INSTRUCTION. INSPIRATION.